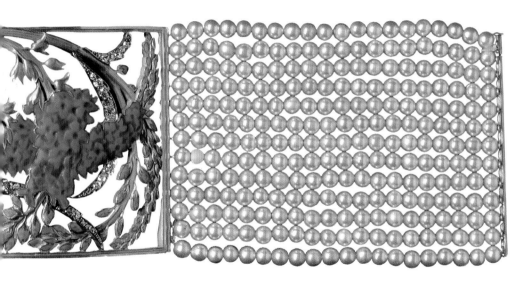

THE WONDERLAND PRESS

The Essential™ is a trademark
of The Wonderland Press, New York
The Essential™ series has been created by The Wonderland Press

Series Producer: John Campbell
Series Editor: Harriet Whelchel
Series Design: The Wonderland Press

Library of Congress Catalog Card Number: 2002114125
ISBN 0-8109-5836-8 (Harry N. Abrams, Inc.)

Printed and bound in China

Harry N. Abrams, Inc.
100 Fifth Avenue
New York, NY 10011
www.abramsbooks.com

Abrams is a subsidiary of

LA MARTINIÈRE
GROUPE

Contents

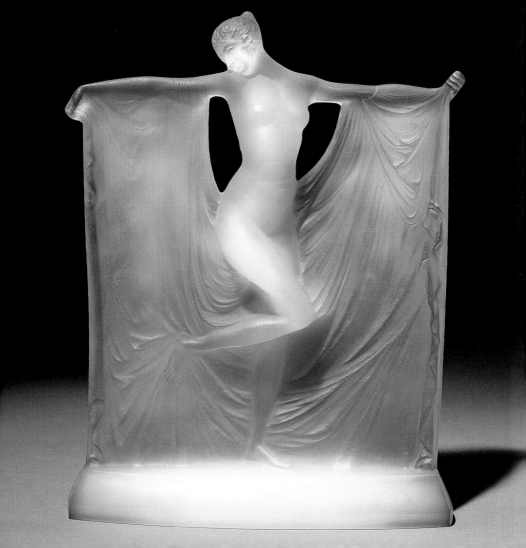

Lalique mirabilis

The French artist **René Lalique** (1860–1945) created a form of art glass so strikingly bold and original the word *Lalique* has now become synonymous with luxury. While few artists succeed in leaving behind a living legacy, René Lalique created a company that not only grew and prospered during his lifetime, but continues to bear his name and which remains in the control of his children and grandchildren. His son, **Marc Lalique** (1900–1977), and his granddaughter, **Marie-Claude Lalique** (b. 1935), have refined and added to the look that has become known as *le style Lalique,* with the result that Lalique creations are among the world's most coveted and collected.

OPPOSITE
"Suzanne"
An opalescent
figurine, c. 1923
Height: 9 ¼" (23 cm)

Sound Byte:
Lalique did for glass what Coco Chanel did for fashion: Lalique is a look. *It is readily identifiable, unique, and at the same time accessible to those who love it.*

—THOMAS HOVING, former director, The
Metropolitan Museum of Art, New York

Today, many artists boast of an intimate knowledge of high technology, only to produce results that are themselves boastful or ironic or so highly obscure as to appear meaningless to an uninitiated public. The Lalique story provides a healthy antidote of intelligence and wisdom:

Not only did he harness the most advanced industrial technologies of the late 19th and early 20th centuries, but he went one step farther and placed them at the service of an art form intended to appeal to the general public, not to an elite. Although many of Lalique's creations were indeed rare and expensive, many more of them were highly affordable, mass-produced, and functional.

Man for all seasons

A Renaissance man known for his tireless experimentation with artistic forms, Lalique enjoyed a career in which he evolved from jeweler to glassmaker and, ultimately, to architectural artist. As a young adult, he cultivated social skills that would later enable him to feel at ease with wealthy aristocrats. His early talent for drawing would serve him well when he trained as a jewelry designer, and the intelligence that led him to become a successful businessman would find a natural outlet when he was faced with managing an enterprise that employed hundreds of workers. He created unique works of art as well as multi-piece, mass-produced table settings. Never one to pass up a challenge, he threw himself exuberantly into opportunities of every kind, whether them involved producing architectural components for gigantic cruise ships or creating a bathtub made entirely of glass. Late in life Lalique even served as curator for his own retrospective exhibition and oversaw the orderly transition of his company to his children.

Getting a head start

Before we launch into his story, here are a few key points about his creative choices that will help you grasp the nature of Lalique's vision and genius:

His inspiration was based on nature: Snakes and swallows, pinecones and orchids, ice and snow—these were the kinds of subjects that inspired the decoration for his jewelry and glasswork. Lalique delighted in highlighting unusual natural materials such as animal horn and misshapen pearls, which were sometimes juxtaposed with precious stones like diamonds and rubies to heighten their effect. In his artwork, he sought to capture nuances of the movements of animals, such as the swooping arcs made by swallows in flight, or to stylize natural events such as as the patterns made by windstorms or schools of fish deep beneath the sea.

He played a leading role in two important artistic movements: *Art Nouveau* and *Art Deco.*

He delighted in changes of scale, from the tiny to the gigantic: Lalique created, for example, huge brooches—some more than nine inches wide and ten inches tall—that were carved in minute detail. When creating jewelry and architecture, he relied on small parts brilliantly composed to create larger themes, such as an ivory plaque intricately engraved to depict women dancing, mounted in a metal frame that had

been encrusted with semiprecious stones. Another example: He would cover the façade of a building with small glass tiles that appeared to be woven together into a tapestry. The result was a pleasing contrast of scale and texture.

He employed solid colors when creating his blown and cast-glass vessels: Whenever Lalique used color in glass, he preferred transparent

monochromes like amber, sea blue, or emerald green. Most of all, he seemed to love icy tints and textures: glass that looked like it was carved from a block of ice or covered with frost.

He focused on beauty and quality: Every Lalique work of art had to look good and be made well or it wasn't worth creating. Unlike other artists, however, Lalique believed that much of his artwork should be sold within the price range of a large middle-class audience. This conviction led him to adapt mass-production techniques, and to open stores that sold his work throughout the world. Some art critics pigeonhole Lalique as a decorative artist, but it is more accurate to view him as a multimedia artist. His mercurial sensibilities led him to adapt his materials and approaches to the project at hand or to the cultural trends of the era. By working in so many media and with such varying styles, Lalique created oeuvres that do not "fit" into categories that scholars and art critics use when classifying sculpture, painting, architecture, and art glass.

He created ensembles of materials and furnishings that had theatrical flair: His panoramic projects ranged from the interior of a fashion house to the grand salon of an ocean liner to the dining table for the president of France. As an architectural artist, he pioneered ways of engineering and integrating his elegant creations into the very framework of buildings, ocean liners, and even passenger trains and automobiles.

OPPOSITE
"Bretonnière"
front (left) and
back (right) of a
gold horn and
enamel pendant.
Carved in high
relief and signed
"Lalique"

9

OPPOSITE

TOP
Aquamarine, pearl,
diamond, and
plique-à-jour enamel
dragonfly pendant
necklace

BOTTOM
Art Nouveau *plique-
à-jour* enamel and
pearl pendant

He made innovative use of industrial techniques when creating his art: These techniques included the miniaturization lathe and mold blowing.

And so the story begins: Throughout his life, Lalique maintained a secrecy that obscured his personal biography, even though it was intended to protect the special techniques he had developed for making art in glass. His date of birth remains the subject of conflicting reports. Some critics list it as June 4 (a Gemini), while others say April 6 (an Aries). But for the record, René Jules Lalique was born on April 6, 1860, in the town of Ay, in the Marne district of northeastern France, about 100 miles from Paris. He was the only child of Jules Lalique and Olympe Berthellemy. Lalique became a Parisian at the age of two when he was taken to the great city where his father ran a small mercantile business from offices on the rue Chapon. However, the family maintained its connections to the countryside and made frequent trips to the Champagne region to visit family members.

Young René grew up loving the beauty of the French countryside, where he developed lasting affection for animals that would later influence his artwork. Toward the end of his life, Lalique would reminisce with his granddaughter, Nicole Maritch-Haviland, about taking long walks with his grandfather in the country, where they explored the world of birds and insects that the forests harbored. Ironically, Lalique's peace-

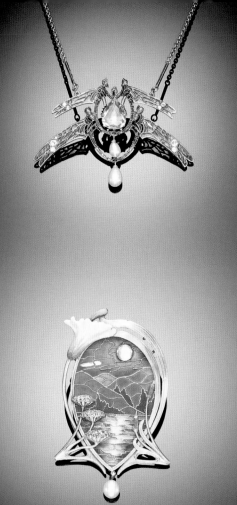

ful childhood took place in dramatic and turbulent times: For example, on July 19, 1870, France declared war against Prussia, only to surrender less than two months later on September 2.

In 1872, Lalique entered the Collège Turgot (a "collège" at that time was approximately equivalent to an American secondary school today), where he studied drawing and received first prize in a drawing competition. In that same year, the artist **Claude Monet** (1840–1926), painted *Impression, Sunrise,* considered by many to be the first Impressionist painting. In 1874, Lalique studied at Fontenay-sous-Bois, and during the summer he earned money by selling ivory cards, decorated with painted floral motifs, to shopkeepers in Épernay.

Sound Byte:
Remember that the most beautiful things in the world are the most useless; peacocks and lilies, for example.

—JOHN RUSKIN, art critic and writer, in *The Stones of Venice* (c. 1845)

After his father died in 1876, Lalique's mother arranged for him to be apprenticed for two years to the goldsmith Louis Aucoc in order to learn the technical skills to become a jeweler. In 1878, at the end of his term with Aucoc, Lalique traveled to England, where he lived until

1880. The impressionable teenager was soon hard at work as a student at the greatest glass and steel architectural wonder of the era—the Crystal Palace School of Art and Music at Sydenham College, located in the reconstructed Crystal Palace exhibition hall that had been the chief glory of the 1851 London Exposition. Lalique delighted in wandering through London's museums, especially the British Museum and the South Kensington Museum (now the Victoria and Albert Museum). During this time, he became a lifelong devotee of the works of **William Shakespeare** (1564–1616).

René Lalique
c. 1913

You must draw well!

During his studies in Paris and London, Lalique trained his hands to draw professionally, but he also absorbed the contemporary culture as a way to train his mind to work artistically. His England was the land of the famous art writer **John Ruskin** (1819–1900) and of **William Morris** (1834–1896), the legendary British craftsman, designer, writer, and typographer, who sought to introduce socialist politics into every aspect of the art world. There was much discussion of how a careful interpretation of nature might revive the arts and crafts. Many of the best talents in the visual arts looked back to the skilled artisans of the Middle Ages for inspiration, and in Paris in 1880, there was an exhibition of the work of the recently deceased **Eugène-Emmanuel Viollet-Le-Duc** (1814–1879). Le-Duc, a French architect, archaeologist, and

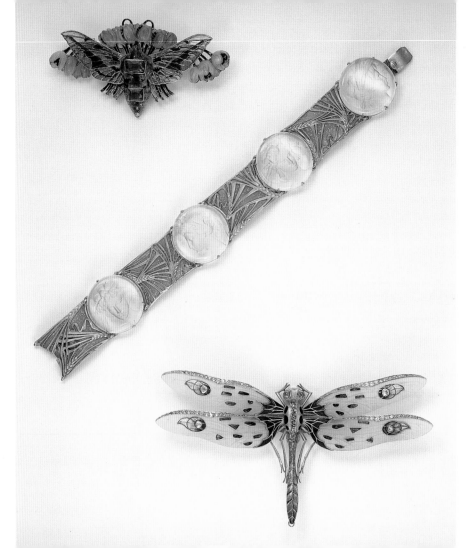

critic who became the leading exponent of the Gothic revival in and showed the world the inherent common sense and splendor of what was at the time a reviled style of medieval architecture. He drew upon these ornate gothic traditions but tempered them with an infusion of simple forms captured through precise observations of the countryside outside Paris. Le-Duc and others advocated careful observation, coupled with skillful drawing, as the elements that would inspire a new generation of talented artists and craftsmen. The young Lalique now had these keys, his talent was wide open, but what would he do with it?

Going nowhere fast

After he returned to Paris, in 1880, Lalique worked as a designer for Vuilleret (who told him that the designs he wanted to execute for jewelry would "lead nowhere") and the following year for a fabricator of jewels, Auguste Petit. In 1882, undeterred by the obstacles facing him, Lalique established his own business, supplying manufacturers and outlets, such as Aucoc, Hamelin, and Renn, with luxury goods. He found time to study sculpture at what is now the École Bernard Palissy, and to contribute to *Le Bijou,* a jewelry trade publication. In 1884, his mother steered him toward a partnership with a family friend, Monsieur Varenne, that would last nearly two years. Their executed designs were stamped "Lalique et Varenne, rue de Vaugirard, 84."

OPPOSITE

TOP
Gold horn enamel gemset dragonfly brooch engraved PW for Philippe Wolfers

MIDDLE
Glass, enamel, and gold bracelet

BOTTOM
Enamel, citrine, and glass Dragonfly brooch

OPPOSITE
Gold and enamel
brooch shaped as
a maiden's head,
with stylized
headress decorated
with sunflowers

The final decades of the 19th century had produced an audience with eclectic tastes in jewelry, and most jewelers maintained a stock in diverse styles, primarily traditional *brightwork*—where the focus was on the quality of the precious gems and metals—or historical revival styles inspired, for example, by the Renaissance or Gothic eras. Few were brave enough to seek a truly contemporary way of creating jewelry. So for the struggling Lalique, this period culminated in a display of his drawings at an exhibition held at the Louvre, which prompted the famous jeweler **Alphonse Fouquet** (1828–1911) to exclaim that, at last, there was a "contemporary" jewelry designer.

Sound Byte:
I was perturbed, troubled at the idea of starting out on a new path…and wondered anxiously whether my new position as a head of a firm would curtail or enhance my liberty.

—RENÉ LALIQUE, 1908, talking about his
acquisition of the Destapes workshop in 1885

Solid gold

By the end of 1885, despite some misgivings at first, Lalique had the self-assurance to accept an offer from the jeweler Jules Destapes (who was eager to enjoy a retirement in Algeria, where he intended to plant

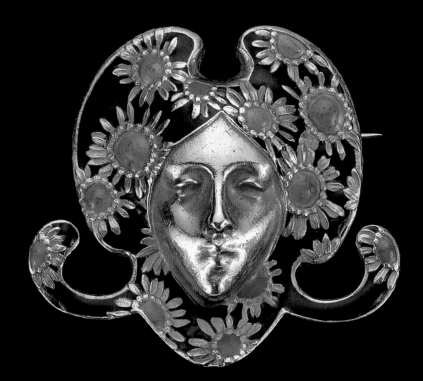

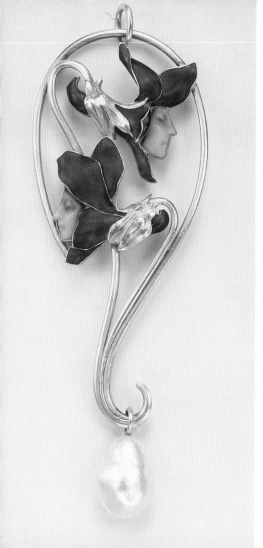

vines for winemaking) to take over his jewelry workshop on Place Gaillon. This represented Lalique's total commitment to pursuing a career as a jeweler. Destapes's chief associate, Paul Briançon, remained at the workshop and Lalique collaborated with him for twenty years. Craftsmen produced Lalique's designs under Briançon's careful supervision. The following year, 1886, Lalique married **Marie-Louise Lambert** and a daughter, **Georgette,** was born later that same year.

Art Nouveau

The artistic movement and style known as Art Nouveau (literally "New Art") emerged in Europe and North America at the end of the 19th century as a style of art and architecture. The 1900 Universal Exposition in Paris helped to affirm the status of Art Nouveau as the leading, predominantly urban, decorative art style of the early 20th century.

The Industrial Revolution that dominated the 19th-century economy posed a series of dilemmas and opportunities for artists. On the one hand, artists were excited by the speed of industrial progress and eager to explore new materials and techniques, such as structural iron and steel for buildings and electricity and lightbulbs for chandeliers and lamps. On the other hand, mass-production techniques invariably led to a decline in the quality of goods produced, and subsequently devalued the dignity long attached to hand work. Art Nouveau artists sought a middle ground, where advanced materials and techniques could be used, but subject to the highest standards of craftsmanship and design.

Many artists and art critics looked to nature as an antidote to the sterility of industrial production. **Charles Darwin** (1809–1882) had published his *On the Origin of Species by Means of Natural Selection* in 1859, and the ensuing public discussion of his theory of evolution appealed to artists as proof that the human species was inextricably entwined with nature. Themes of metamorphosis and the exotic, sometimes horrific, blending of animal, vegetable, and mineral forms soon became a staple of the Art Nouveau tool kit. The famous "whiplash" and serpentine lines now associated with Art Nouveau also represented this attempt to make visible the energy and dynamism of an era when nature and industry struggled for the soul of humanity. Out of this merging of forms, the Art Nouveau artist sought to create a "total

OPPOSITE
Gold, enamel, and pearl pendant designed as two entwined, enamel violets with grey enamel pistils, representing maidens breathing their perfume. c. 1897–99

artwork," a world where every detail existed in harmony with every other detail, from the ring on your finger to the shoes on your feet to the building in which you ate dinner or the machine you used to earn your living.

The leaders of the Art Nouveau style in France included Lalique and **Émile Gallé** (1846–1904), who owned a large industrial complex in the town of Nancy but devoted most of its resources to producing extraordinary glass, ceramic, and wood works, including glass chalices swarming with dragonflies and surreal mushroom lamps that evoked drug-induced reveries. His creations were sought after by the French elite—**Marcel Proust** (1871–1922) ordered pieces. Other leading exponents of the Art Nouveau style included **Hector Guimard** (1867–1942), who designed the dramatic entrances for the brand new Paris subway system (between 1898 and 1901); **Louis Majorelle** (1859–1926), who created extraordinary pieces of inlaid furniture; and **Louis Comfort Tiffany** (1848–1933), in the United States, famous for his stained-glass lamps. **Henri de Toulouse-Lautrec** (1864–1901) was sometimes considered an Art Nouveau artist, especially in his graphic work and posters.

Trinkets?

By the age of 26, Lalique had established himself as an independent and highly innovative artist-jeweler. He moved to more spacious quarters

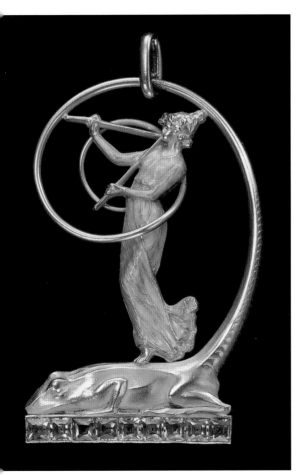

ABOVE
Gold, enamel, and chrysolite pendant

LEFT
Diamond, enamel, pearl, and glass pendant

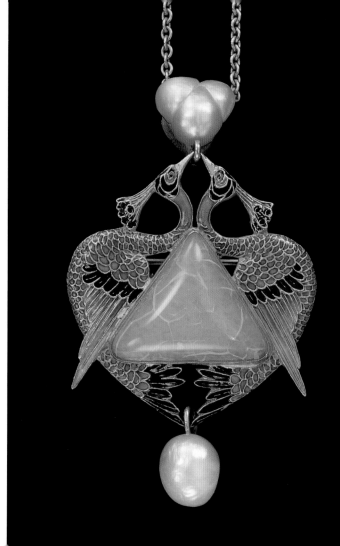

THIS PAGE
Enamel, opal, and
pearl brooch pendant

OPPOSITE PAGE
Gold, enamel, and
diamond brooch

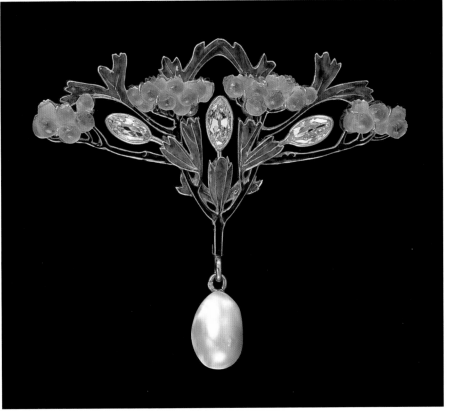

at 24, rue Quatre Septembre, and began to develop the extraordinary Art Nouveau designs that launched a new style in French jewelry. From 1887 on, Lalique produced an almost uninterrupted sequence of diminutive masterworks. He saw his creations as miniature paintings or sculptures rather than flashy ornaments intended to mesmerize and impress. He chose to use precious stones like diamonds and rubies in supporting roles, focusing the spotlight instead on the interplay of foreground and background, the arrangements of elements, and the synthesis of different kinds of materials including glass, horn, coral, ivory, and enamel. Unlike the highly popular monochromatic, faceted, and polished jewelry of the era that was sometimes called brightwork—such as a diamond necklace with maybe a single color note contributed by a large central ruby—Lalique delighted in the subtle harmonies of colors and textures that he achieved by blending diverse, and sometimes unorthodox, materials. He generally based the designs for the jewelry upon life studies from nature that he had prepared on paper, using ink, watercolor, or gouache.

Enamel, glass, and gold bracelet

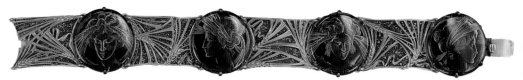

Flight of swallows

In 1887, Lalique designed an ambitious corsage ensemble called the *Flight of Swallows*. Although he used traditional jeweler's techniques, the design was nonetheless inspired and innovative. Based on his observations of the arcing flight of diving swallows, he captured the perspective shifts in the size of the birds by making individual jeweled forms of varying sizes. At first rejected by the jewelry firm of Boucheron, it became a best-seller. Women loved the fact that the birds could be worn individually or grouped together "in the hair or at the belt."

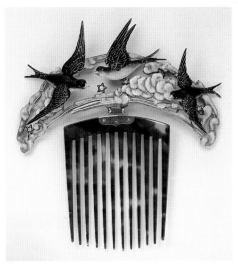

Enamel and diamond comb, signed Lucien Gaillard

Cave dwellers' drawings from at least 20,000 years ago provide some of the earliest evidence of the love of mankind for ornamentation. The first ornaments were probably made from animal and vegetable products like bones and claws, feathers and vines. Beach pebbles could easily become strings of beads and eventually necklaces. From very early times, jewelry was valued for its magical and symbolic associations: Amulets might have the power to repel evil spirits or protect against diseases.

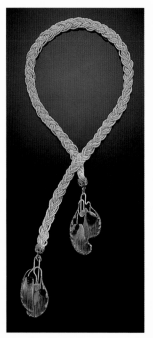

These primitive ornaments evolved over time into more luxurious forms of jewelry that incorporated precious metals like gold and silver and rare gems such as diamonds, emeralds, and rubies. Jewelry began to change, or perhaps rather expand, its functions. In the modern era, jewelry can be divided into three broad group, based on the types of people who own it: wearers, investors, and collectors. Lalique created jewelry that might be worn (frequently by actresses on stage or by wealthy patrons posing to have their portraits painted), but it appealed primarily to collectors. The intrinsic value of the jewelry, the amount of gold or the number of carats of diamonds, was of far less concern to him.

Lalique considered himself a goldsmith but not a traditional jeweler. He found the highly conventional geometrical, chiseled shapes of precious gems such as diamonds and rubies far too stifling to his creativity. Rather than looking deeply into diamond mines for the sources of his inspiration, he looked deeply into contemporary painting and sculpture. This required him to create new techniques and use unorthodox materials. For example, glass could be molded into shapes no diamond cutter could ever hope (or afford) to achieve. Lalique was even bold enough to place glass and diamonds side by side in the same piece, a first in the history of jewelry!

Lalique saw much of his jewelry as three-dimensional sculpture. While traditional jewelers seldom thought in the round, Lalique took inspiration from Renaissance jewelers and frequently finished the backs of his precious pieces, even if they would never be seen by anyone other than the wearer, or maybe the museum curator!

Most Lalique jewels began life as a working drawing created by the master himself. On these drawings, he drew the work to size and indicated details such as the thickness of the gold, the types of gems and semiprecious stones and other materials to be used, and sometimes the name of the client.

The working drawings were then executed by the employees of his studio (up to about 30 people).

Gold

Gold (usually yellow, sometimes green-gold, colored with cadmium in alloy) was Lalique's chosen material for the armature of his work. Gold is easily worked, and can be cast into a variety of shapes in molds using the lost wax technique (a process of forming the model in wax, and then encasing the wax in a mold material; the wax is then heated up so that it will melt and evaporate, leaving a hollow mold—thus the term "lost wax"). "Thick" sheets of gold (gold plate approximately 1/10th inch thick or less) could be cut into shapes that matched those in the drawings, and then engraved or cut out to receive inlays—for example of enamels. The gold plate could also be stamped with a die, creating the effect of embossed paper.

ABOVE
A partially gilded, silver amethyst and opal belt buckle depicting night and day

OPPOSITE PAGE
Opalescent glass, diamond, and pearl *sautoir*

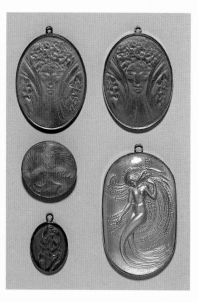

Glass pendants and brooches

Art Nouveau glass, citrine,
diamond, and enamel bracelet

Jewels

Like his American contemporary **Louis Comfort Tiffany** (1848–1943), Lalique showed little admiration for the intrinsic value of precious stones. He was, however, excited by the idea of combining precious gems with other materials in order to achieve novel effects, or to create a harmonious ensemble. For example, in the brooch *Women and Flowers* (c. 1904), Lalique used square-cut diamonds as anchors for the four corners of the design, but pride of place was given to oblong panels of engraved glass showing female nudes scattering flowers.

Enamels

Enamels are glass powders mixed with water that can be applied to a surface with a brush, like oil paints. For Lalique, the "canvas" was usually gold plate. Metal oxides provided the color and heat from the oven melted the glass, binding it to the gold. The depth of the color could be influenced by the thickness of the enamel layer, and this could be controlled by cutting deeply, or shallowly, into the gold. The shiny surface of the gold creates a mirror effect that reflects light back through the (usually) transparent enamels.

Lalique used special enameling techniques such as champlevé and plique-à-jour. In the former, hollows were engraved into the gold ground as receptacles for the enamel, and the crests between the hollows acted like a line in a drawing. In the latter, the technique produced results resembling a miniature stained-glass window, the enamel "panes" held in place by openwork gold "framing."

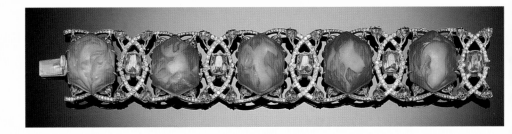

Glass

It was perhaps obvious that Lalique's interest in gems and unusual materials would lead him to explore glass enamels and later cast-glass elements in his jewelry. The techniques he had learned for casting and engraving gold are easily adapted to glassmaking. As with some of the earliest uses of glass in the ancient world as an imitator of semiprecious stones, Lalique soon came to value the chameleon qualities of glass as a kind of infinitely malleable and colorable artificial gemstone. (See *The ABCs of Glassmaking* on pages 62–68 for more details.)

Other materials

Lalique also delighted in using "unorthodox" materials in his jewelry. Some of these, like pebbles and horn and irregularly shaped pearls, were used in primitive societies and in ancient times or as recently as in the Renaissance, but relatively unheard of in French high fashion.

The reducing lathe

From about 1892, Lalique employed an extraordinary machine that gave some of his jewelry a "how did he do that?" quality. This was the reducing lathe, frequently used in mints to create medals and coins. Lalique could make a "life-size" model and, using the tracing needle on the lathe, which was connected through an elaborate mechanism of gears to a cutting tip, could create a miniature copy in ivory or gold. He also used this machine to produce detailed molds for casting metal and even glass.

A team sport

By 1890, Lalique had outgrown his quarters and moved to an even larger space at 20, rue Thérèse, where he employed 25 to 30 assistants. He decorated the interiors according to his own taste, even having the tables and chairs made to his specific designs. Inspired by the new surroundings and energized by the presence of a skilled team able to execute his every plan, Lalique began a period of intense productivity. He also met **Augustine-Alice Ledru,** the daughter of sculptor Auguste Ledru. First his muse, she later became his wife.

Sound Byte:
I worked ceaselessly, making drawings, models, studies, and technical trials of all types without a moment's rest, striving to achieve new results, to create something that has never been seen before.

—RENÉ LALIQUE, c. 1892

Glass seduces

It was typical of Lalique that, even as he approached his greatest success with jewelry, he was also laying the groundwork for his next campaign. So, around 1891, Lalique began his earliest research with glass as an independent medium for art. He is thought to have become

interested in the material for its own sake after using powdered glass enamels on the metal in his jewelry.

He set up a small glassmaking studio within his atelier, and his friends Jules Henrivaux (director of the Saint-Gobain factory) and Léon Appert provided support and advice. The brothers Adrien and Léon Appert ran one of the most successful glassworks in France, where they made stained glass for windows and optical glass, as well as laboratory glassware and a continuous stream of experimental colored glasses, including opalines, glasses that resembled opals. The jeweler

A selection of Lalique objects

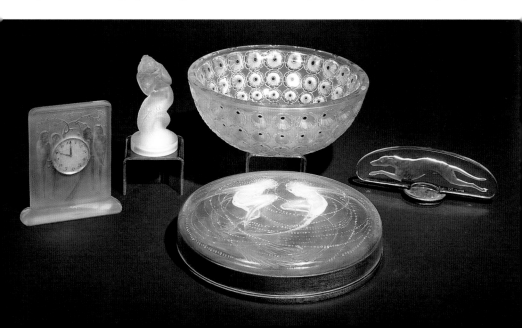

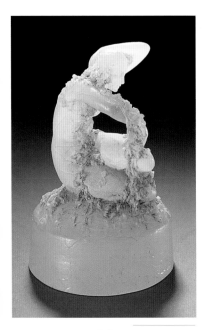

A fine *cire perdue* vase

and writer **Henri Vever** (1854–1942) described visits *chez* Lalique, where the atmosphere was like that of an alchemist's lab, ornamented with "very curious pieces executed in glass" including a little head of the decapitated Saint John the Baptist, "full of expression."

Two jewels

On May 4, 1892, a daughter, **Suzanne,** was born to Lalique and Augustine-Alice Ledru. It was during this time that he began to totally revise his conception of the *bijou* (jewel). He wanted to create something "never seen before."

The Valkyrie: A music case

Art Nouveau artists envisioned an ideal world where all the arts were united and where even the smallest ornamental detail was worthy of the artist's attention. Lalique exhibited an intricate binding, intended to accommodate the score of **Richard Wagner**'s (1813–1883) opera, at either the 1893 or 1894 Salon de la Société des Artistes Français. Wagner's music was popular with French artists of the era, who were also attracted to the composer's idea of the *Gesamtkunstwerk* or total artwork.

The poppy seed and smoke decoration along the border of this case was a favorite device of symbolist artists when they wanted to evoke images of opium dreams and fantasies, or more generally the sources of artistic creativity. The ivory panel (divided into two parts by a stylized poppy) depicts several of the Valkyries on horseback (to defend Valhalla, the home of the gods, Wotan, the head of the gods, fathered nine warrior daughters, known as the Valkyries). The scene was probably created from a larger model using a reducing lathe. The Wagnerian concept of the total artwork has parallels here in the idea that

Angels and Perfume Burner
A clear, frosted box and cover,
c. 1912. 3 ¼" (8.3 cm)

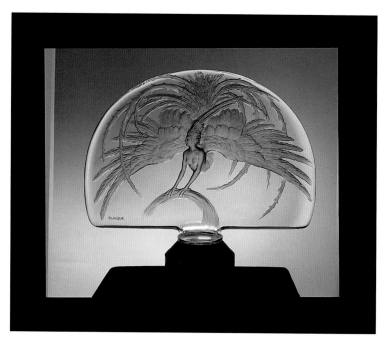

the world can be miniaturized (and so by implication held in the palm of the hand, like a book) and in **Jules Verne** (1828–1905), by the idea that the world can be completely and rapidly explored, as in his novel *Around the World in Eighty Days* (1873).

Women and snakes

Snakes have long been associated with precious stones, maybe because they were a hazard to those who explored among rocky places to find the sources of gems. Diamonds are thought to protect their bearers from snakes in Hindu mythology. The snake's sinuous form seemed perfectly suited to Art Nouveau's love of flowing geometries, and Lalique adopted the snake for some of his most dramatic jewelry, such as the corsage ornament *Snakes* of 1898–99. However, Lalique's forms are never disturbing—his unflagging interest was in the beauty of nature and of the female form on which his jewelry would become a

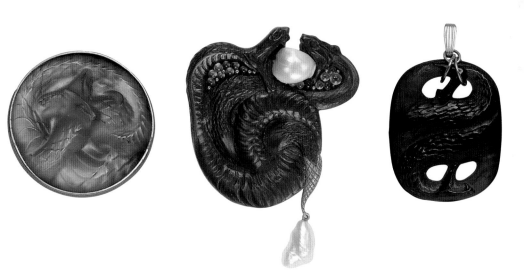

chief ornament. A Lalique snake pinned on a woman or carried as a purse, was intended to accentuate her allure and mystery.

Femmes fatales, aesthetic aristocrats, and compulsive collectors

Ivory medallion of
Sarah Bernhardt
1896

During the time leading up to the Paris 1900 Universal Exposition, Lalique began creating jewels for the famed actress **Sarah Bernhardt** (1844–1923) to wear on stage, most notably in her performances as Salome. His patrons among the aristocracy included the decadent Robert de Montesquiou, who was the inspiration for Baron de Charlus in Marcel Proust's *Remembrance of Things Past*. And from 1895 to 1905, he created more than 150 significant works for his most important patron, **Calouste Gulbenkian**—treasures that are today housed in the Gulbenkian Museum in Portugal.

My *bijou*

The famous Art Nouveau artist Émile Gallé wrote in an article in the *Gazette des Beaux-Arts* of 1897 that Lalique was the inventor of the modern French *bijou*, remarking that Lalique's jewelry had an elegance of line, an appealing sobriety in the midst of its prodigality, and that it evoked in the viewer a feeling like that of listening to an exquisite piece of music. In the same year, Lalique was "knighted" a Chevalier de la Légion d'Honneur.

Art star

Between the years 1895 and 1900, Lalique changed the world's conception of jewelry, single-handedly lifting it out of the fashion world and elevating it into the domain of high art. Museums in Paris, New York, London, and Berlin, competed to acquire his creations, and he became a celebrity as members of the aristocracy, the business and political worlds, and the theater world avidly sought to own his work.

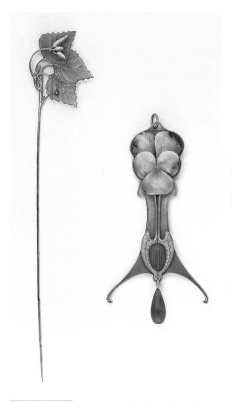

Horn and enamel hatpin (left) and opal, enamel, and glass pendant (right)

These rock–hard kernels of light which "ripen" in the bowels of the earth are regarded as the very essence of a natural perfection that no art can equal; they were even traditionally thought to have occult powers.

—MARIE-ODILE BRIOT, curator of
the Musée Galliera, Paris, 1998

OPPOSITE
Dragonfly
pendant necklace
c. 1903–05. Gold,
translucent enamel,
diamonds, and
aquamarine

Triumph in 1900

The Exposition Universelle in Paris in 1900 was one in a series of extraordinary world expositions that took place in Europe and America from roughly the middle of the nineteenth century to the start of World War II. Although such expositions continue today, their importance as a means of exposing masses of people to innovations has diminished. But in 1900, such novelties as electric lights and a moving sidewalk were enough to draw 50.8 million curious people through the gates in just six months. The often-heard description of Paris as the "City of Light" may have originated on the grounds of the exposition, where there was even a "Palace of Electricity."

Sexual electricity was also in the air. The exposition fell in the second half of the Belle Epoque in France, which lasted from 1871 to 1913. It was a time when relations between the sexes were in flux and the upper and bohemian classes were testing the boundaries of sexual freedom, for example, experimenting with cross-dressing and sapphism. Absinthe was

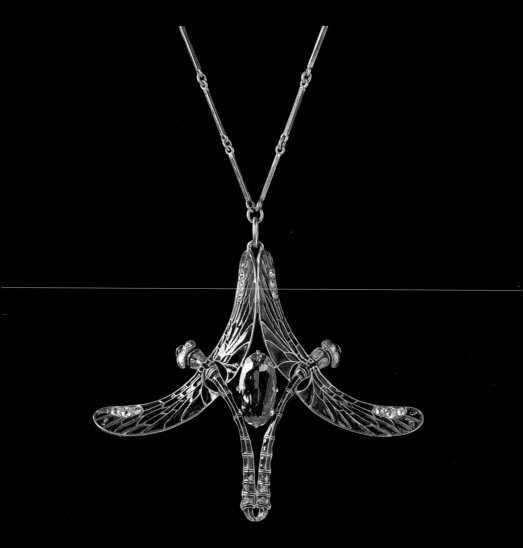

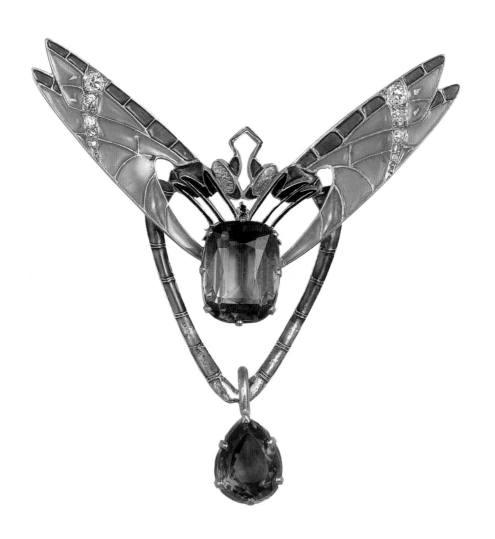

a favorite drug (a fermented concoction of wormwood, anise, and fennel) as evidenced in paintings by Toulouse-Lautrec and other artists, and Impressionism and Art Nouveau were the triumphant art movement.

Sound Byte:
Lalique triumphed in unparalleled fashion: a dense and fervent crowd gathered round to see works that were on everyone's lips.
—HENRI VEVER, writer, jeweler, collector, 1908
(writing about the 1900 Exposition Universelle in Paris)

Lalique (along with Émile Gallé) was a star at the Paris 1900 Exposition. Masses of people surrounded his display, where the extraordinary jewelry (more than 100 items) was laid out like a meadow of wildflowers in vitrines decorated with bats flying overhead against a twilight sky and backdrops of bronze butterfly-women. Enthralled critics wrote that Lalique was an "indisputable" pioneer of Art Nouveau who freed jewelry from its highly conservative luxury traditions, expanding the range of the bijou to include a wide assortment of materials and greater color harmonies. A new generation of jewelry artists was inspired to adopt themes that Lalique had been among the first to explore, based on flowers, insects, the cycles of nature, and the passions of man and woman. These included the jewelers **Georges Fouquet** (1858–1929) and **Henri Vever** (1854–1943), although their work tends to be more geometrically stylized.

OPPOSITE
Plique-à-jour dragonfly pendant brooch

In recognition of his success, Lalique was elevated to an Officer of the Légion d'Honneur. And on September 1, a son, Marc, was born.

But not everyone applauded Lalique's achievements: Some critics remained unconvinced, finding the work *too* original. These doubters included Fritz Minkerslinz, who wrote about the 1900 exposition and described Lalique's jewels as "eccentric, unwearable, mere showpieces or museum objects." And there was a certain truth in this: Lalique's jewelry was seldom worn to parties or on the street.

Neckband. 1899–90
Gold, enamel,
faux pearls
2 ¼ x 9 ¼ x ⅘"
(5.7 x 23.5 x 2.1 cm)

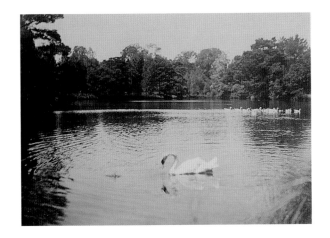

René Lalique
Photograph of a
swan at Lake
Clairefontaine,
c. 1926

FYI: **Lalique as photographer**—In 1898, the Laliques were given
property at Clairefontaine near Rambouillet. It was here that Lalique later
built a small atelier for making glass, and he enjoyed strolling through
the idyllic parklike countryside, which included a pond. Lalique began
to carry a camera in this setting, and according to his granddaughter,
Nicole, the resulting photographs inspired some of his most "auda-
cious" pieces of jewelry. One drawing that he made for a pendant was
even annotated with a reminder to "do another...directly from
nature...the photograph will suffice for the flowers."

OPPOSITE
(Clockwise
from top left):
"Sunflower"
(*Tournesol*), an
electric-blue,
oviform glass vase;
"Ceylan," a blue-
stained opalescent,
clear, and satin-
finished glass
vase wheel; "Two
Entwined Sirens"
(*Deux Sirènes
enlacées, assises*),
a satin-finished,
glass blotter;
"Nymph" (*Naïade*),
an opalescent
glass figure

Ice man

As Lalique gained proficiency in glassmaking techniques, glass elements began to occupy a greater place in his artwork. A vitrine displaying work at the Salon in 1901 was decorated at the corners with four threatening upright glass snakes, their heads facing into the case and their mouths open displaying fangs. One writer described the bodies of the snakes as shining with "the bright, grayish transparency of flowing ice." Over the years, many writers have made the comparison between Lalique's glass and ice, sometimes finding the work cold and distant, sometimes exulting in its arctic brilliance.

A family business

On July 8, 1902, Lalique married Augustine-Alice Ledru. They occupied the townhouse at 40, Cours-La-Reine (later cours Albert-Ier). This move combined his residence and his workshop/studio (although for fire-safety reasons the glass furnaces were installed on the piece of land they owned at Clairefontaine in the countryside). The edifice, which still stands, was embellished by Lalique: He designed some of the decorated stonework, inspired by "every species of pine"; and the door to the exhibition hall included panels of cast glass depicting human figures. That door opened on to a room lit with custom-made hanging chandeliers ornamented with chameleons and entwined serpents.

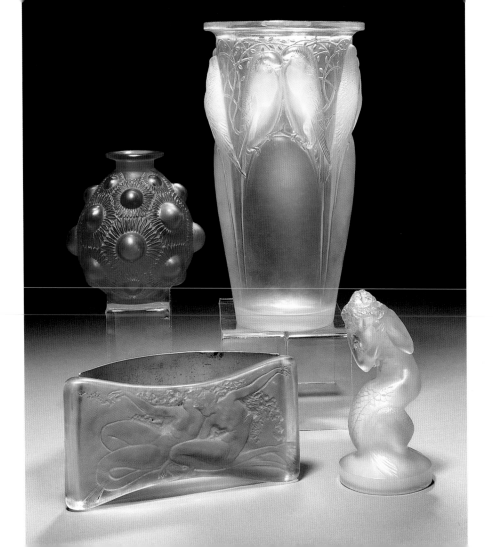

Reptiles

Lalique liked to use snakes and lizards and frogs as decorative themes in his work: They were ideally suited to the exotic themes and sensuous organic lines that Art Nouveau artists adored. In 1903, he exhibited a purse decorated with snakes, and between 1897 and 1901,

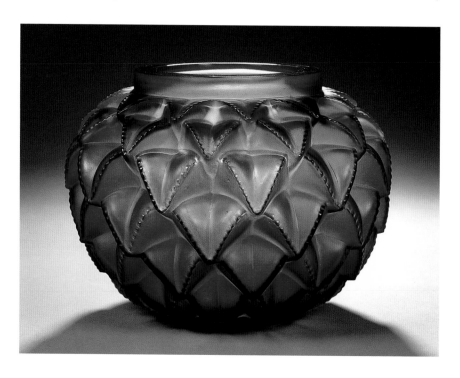

he created a *Snakes* sugar bowl and a *Lizard* lorgnette (opera glass) intended to be held by the tail.

Sound Byte:
Lalique's work was finally introduced to the United States—he had not appeared in previous American public exhibitions, and this was the first opportunity to see his works in "real life." Wealthy American collectors were able to secure the best "jewels" at very high prices.

—GABRIEL P. WEISBERG,
Art Nouveau, 1998

Parisian in America

In the same year that Émile Gallé, Lalique's chief peer in French Art Nouveau, died, Lalique participated in the 1904 St. Louis Louisiana Purchase Exposition. He traveled to the United States for the exposition, staying along the way in New York City and Buffalo. His work was well received by the public, who so overwhelmed some of the Tiffany and Lalique displays that armed guards were hired. Fans included **Alice Roosevelt Longworth** (1884–1980), daughter of the president, and the collector **Henry Walters** (1848–1931), who bought nine pieces that formed the nucleus of the Lalique jewelry collection that later became one of the treasures of the Walters Art Gallery in Baltimore.

OPPOSITE
"Languedoc"
Emerald-green
vase with satin-
finished glass,
molded with bands
of overlapping,
stylized leaves

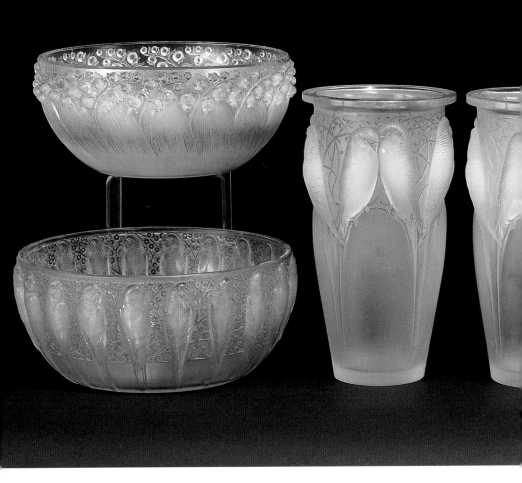

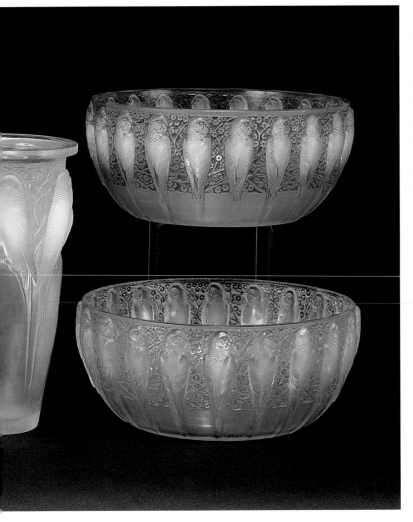

(From top left): "Muguet," a blue-stained, opalescent, clear, and satin-finished glass bowl (2 of them); "Perruches," a blue-stained, opalescent glass bowl (2 of them); "Ceylan," a blue-stained, opalescent glass vase (2 of them)

OPPOSITE
LEFT
"Two Peacocks"
(*Deux Paons*)
Molded-glass
perfume bottle

RIGHT
A clear, frosted-
glass perfume
bottle and stopper

Open for business

In 1905, Lalique opened a major new outlet store for his work on the elegant Place Vendôme in Paris, and at the same time the Musée des Arts Décoratifs in the Louvre complex opened.

The scent of success

In 1908 René Lalique began to work with a friend, the perfumer **François Coty** (1874–1934), to create an innovative series of perfume bottles that captured the character of each fragrance in the shape, color, and decoration of the bottle, changing forever the way perfumes were marketed. It seemed almost too appropriate. Lalique loved nature and sought to capture its most intimate and ephemeral moments in jewelry designed to enhance the female form. He now glided effortlessly into a new realm, one where the distillates of nature were pressed into intimate contact with the female form through the agency of his brilliant flacons, bearing names like *L'Idylle, Cyclamen, Styx,* and *Ambre antique.*

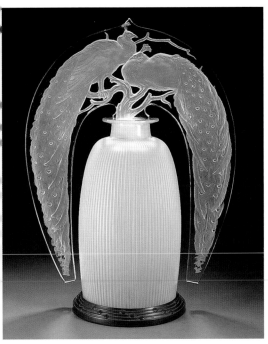

And in a stroke of marketing genius, if customers wanted to own an original Lalique bottle, they had to buy the perfume. Lalique even created a perfume tester called *Renommée d'Orsay* for the D'Orsay perfume house in 1922, which consisted of a solid block of glass with five perfume wells, capped by glass flower stoppers.

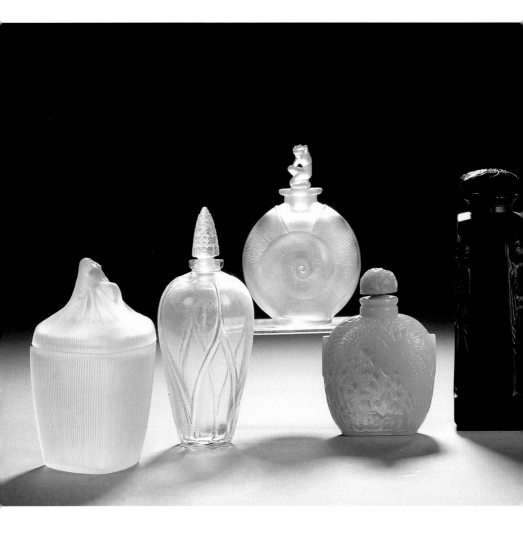

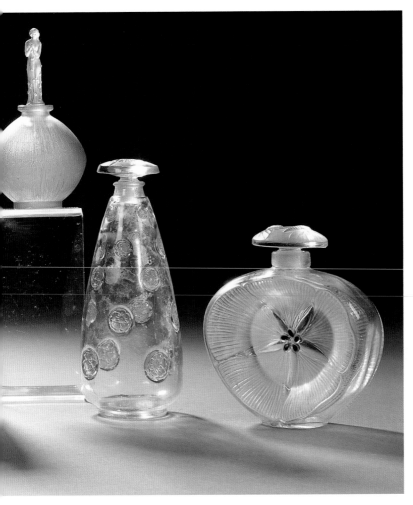

This success, at age 48, launched Lalique into a new career, and he was soon creating elegant bottles for the perfume houses of Nina Ricci, Guerlain, Houbigant, D'Orsay, Coty, and Worth. In order to meet the demand, Lalique had to mass-produce the bottles using industrial production techniques like molding and pressing (see *The ABCs of Glassmaking* on page 62–68), and this led him to create a booming business supplying tableware, vases and other ornamental items to the affluent middle classes. In the autumn of 1908, he decided to rent a glass factory at Combs-la-Ville near Paris, and on February 17, 1910, he was issued a patent for a process for molding glass in order to fabricate flacons, carafes, and other vessels. His decade of triumphs was brought

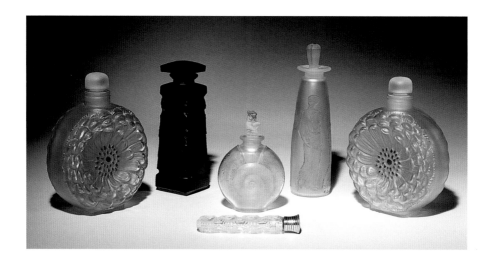

to a crashing halt when his wife, Augustine-Alice Ledru, died in 1909, and his daughter Georgette passed away the following year.

Adieu *bijoux!*

As the new century entered its teens, Lalique bowed out of the jewelry trade with a final show, in 1911, at Place Vendôme. His architectural glass business heated up, and he made the glass doors and architectural panels for the Coty shop at 712 Fifth Avenue (now the Henri Bendel store) in New York City.

Married to glass

Lalique purchased the Combs-la-Ville glass factory in 1913, and this represented his total commitment to large-scale glass production. Hard at work on technical innovations, and eager to protect his art from imitators, he applied for many more patents, including a complex multiple-part process for molding and shaping blown glass, and a clever one for concealed lighting.

OPPOSITE
(from left) "Dalia," a blue-stained perfume bottle and stopper (same bottle at right); "Ambre d'Orsay," a black-glass perfume bottle and stopper; "Amphytrite," a blue-stained perfume bottle; Lalique perfume bottle with metal cap

Sound Byte:
Prior to René Lalique, what was jewelry? Obviously ornament, but also a crude kind of luxury. The old jewel was based upon the idea of wealth; the new is built upon an artistic idea.

—GUSTAVE KAHN, poet, 1905

Lalique's various studios and factories

Over time, the scale and ambitions of Lalique's production required larger and larger studios and factories. After moving from his jewelry Atelier on place Gaillon, he occupied several locations:

- 1888–1902: Lalique occupied the atelier at 20, rue Thérèse

- 1898–1908: He opened an atelier at Clairefontaine, in the country-side near Rambouillet, on about 40 acres of land. This atelier was built for glassmaking.

- From 1909: the factory at Combs-la-Ville, where he converted a factory owned by the Compagnie Générale d'Électricité for use as his glass factory. He rented it from month to month until he purchased it on September 30, 1913. Here, Lalique began his first large-scale production of glass objects. During World War I, production was diverted from art to the manufacture of various bottles and other glass items needed in hospitals and laboratories. The glass furnaces were kept in use here until 1956.

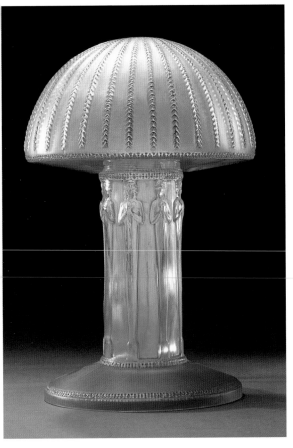

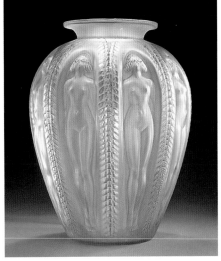

ABOVE
A monumental, molded-glass vase

LEFT
Molded-glass table lamp

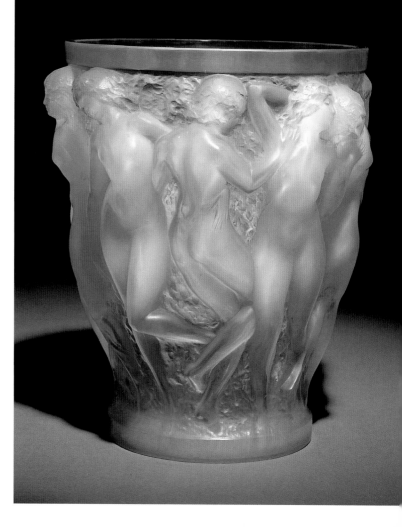

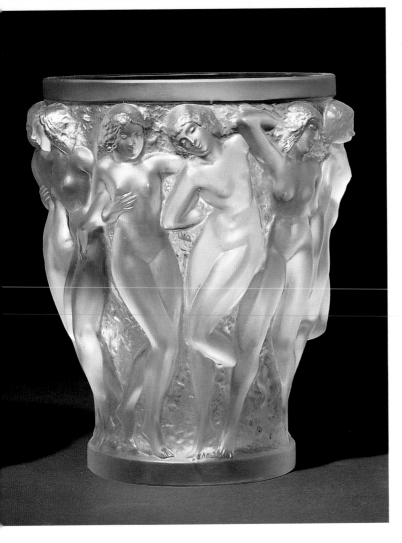

- From 1921: Lalique's needs soon outgrew Combs-la-Ville, so he built a larger factory at Wingen-sur-Moder, which he christened "La Verrerie d'Alsace." In 1923, his son Marc took over the direction of the factory. At first, Wingen was devoted to the simpler, mass-produced works, while Combs-la-Ville focused on producing the more prestigious artworks. But this changed over time as Wingen, too, began to handle more complex objects.

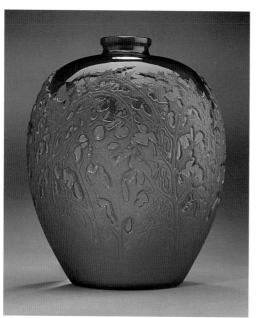
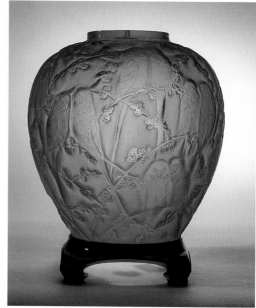

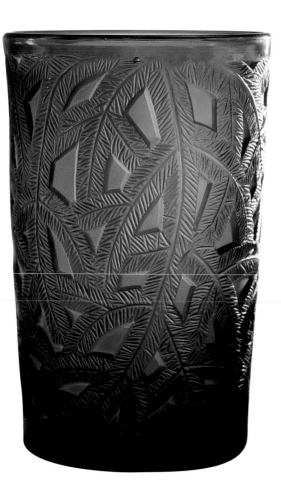

LEFT
"Epicea"
A green, clear, and
satin-finished molded
glass vase

OPPOSITE
LEFT
"Perruches"
Red molded glass vase

RIGHT
"Perruches"
Blue glass vase with
cast-bronze base

Origins of glassblowing: Glassmaking is built upon ancient techniques and traditional forms, and much of its vitality comes from adapting these processes and shapes to ever-changing tastes. The basic steps in glassworking have remained essentially unchanged since the time of the Roman Empire, when glassblowing was invented.

The hot shop: Glassmaking is done in a *hot shop* or factory. Although details varied over the years, in general the Lalique factories contained furnaces or pots for melting colored glass or clear glass, where the molten glass was held in the range of 2550 F. There were also reheating chambers known as *glory holes.* Finished pieces were allowed to cool in *annealing ovens* at a controlled temperature over a period of time to reduce tension within the glass.

The team: Unlike other forms of art, such as painting or sculpture, hot glass requires teamwork. The person in charge of the piece being created is called the *gaffer.* He (or more recently she)

"Medici" or "Four Figurines" Emerald-green ashtray, c. 1920 Length: 5 ¾" (14.5 cm)

is the team leader and has one or more assistants who blow the glass at the bench while the gaffer shapes the piece; they also shield the gaffer's arm and hand from the hot glass and bring bits of glass and **punties** (defined on page 64), prepare colors, and generally help out as needed.

The design: Most of the ideas for artworks originated in the mind of René Lalique. Sometimes a single design required 10 or 20 preliminary sketches, and then a finished design. Many of these, with annotations in the artist's own hand, still exist. The completed design was sent to the atelier or factory, where Lalique's employee-collaborators would adapt the design to the contingencies of production by creating a series of three-dimensional clay models for comparison and study, and sometimes eventually a steel mold. Some designs were produced almost wholly by the artist's closest associates, who had learned the Lalique "style" and "sensibility." We know the names, and not much more, for a few of these designers, including Chardon, Mademoiselle Riard and François Barette. A sculptor, Maurice Bergelin, assisted with the creation of the three-dimensional models that were used to cast the lost wax glass artworks.

The earliest works: Some of Lalique's earliest works in glass were made by a simple process of ancient origins: He would create a hollow refractory mold (a mold made from a malleable substance like clay that could withstand high temperatures when hardened), and then melt glass into the mold. Once cool, the mold could be broken away from the glass. This technique was suited to making small components for jewelry, or perhaps a limited amount of experimentation with the casting of architectural elements like glass tiles.

Glassblowing

Tools: The glassblower's tools have remained virtually unchanged for hundreds of years. Most tools are made of steel or wood. Glassblowing tools are expensive; a basic set, including a **blowpipe,** shears and other tools, costs about $500 today.

Temperature: Glassblowing requires a dance between extremes of temperature. If the glass is too hot, it will flow like honey and lose its shape. If the glass cools down too much, it will become too hard to blow and may crack off the pipe and shatter on the floor. The gaffer must maintain an even temperature by constantly reheating the glass in the **glory hole** (or by using hand-held blowtorches), and by stopping the heating process before the glass becomes too "floppy."

Here's how it works:

Mixing the ingredients: The raw materials for glass are **silica** (i.e., *sand or quartz)* and **flux ingredients** that make it easier to melt the silica by lowering the melting point of the sand. (These ingredients also make the glass more resistant to decay and provide color and texture.) This batch is shoveled into a furnace where it can be melted into a liquid.

Gathering the glass: The **molten glass** (i.e., glass that is hot and melted) is extracted from the furnace on the end of a carefully machined, hollow piece of steel pipe called a blowpipe, the basic glassblowing tool. This produces the first **gather** of glass. If you've ever removed honey from a jar with a wooden stick, you're familiar with this process. The blowpipe is continually rotated to keep the gather of glass centered, as with a glob of honey. It is possible at this or at later stages to add color to the glass.

Blowing bubbles: The first gather of hot glass is rolled on a steel table called a **marver.** A large bullet-shaped solid mass is created at this stage, thereby forming the beginning of the glass vessel. The glassblower breathes air into the blowpipe and a small bubble emerges at the other end, within the mass of molten glass. After the gather has cooled, additional layers of glass can be built up around the initial gather. Wooden paddles are used to flatten the end of the bubble, creating what will become the **foot,** or flat bottom, of the piece. Ladlelike **blocks** are used to shape a bubble into a perfect round shape. This stepwise process enables the artist to work the shapeless mass into an infinity of forms and sizes.

Modifying by reheating: To prevent the vase from breaking apart, the gaffer will often hand his blowpipe to an assistant, who takes it to a special kind of furnace, the glory hole, for reheating. There, the rapidly cooling glass is softened by a blasting flame and made ready for reworking. The shape, exceedingly hot from the glory hole and rapidly slumping under the weight of gravity, can be adjusted by the skilled team. Any problems can be repaired at this time.

The punty: Once the basic shape of a piece is established on the blowpipe, it is time to open up the mouth of the vessel. Steel or wooden tongs called **jacks** are used to disconnect the neck of a piece from the blowpipe and transfer it to a **punty,** also called a **pontil rod.** Unlike the blowpipe, which is hollow, the punty is made of solid steel and is used to hold the hot glass during

the final stages of glassblowing. It is fused to the end of the gather, at the foot of the piece, opposite the end to which the blowpipe had been fastened. Special **scissors** or **shears** can be used to cut the molten glass, trim the lip or mouth of the vessel, open up the bubble, and form the rim. If the vessel requires a handle, a foot, or some three-dimensional decoration, a studio assistant can bring a specially shaped solid **bit** of hot glass to the gaffer at the bench, where it is fused to the object being made and cut off with scissors. The **open neck** of the piece, where it had once been attached to the pipe, becomes the neck of the glass vase or the mouth of the bowl. Paddles are used to finish the mouths of vases and bowls once the piece is on the punty.

Molding

At the Lalique factories, many of the glass objects were made by a variation on free-hand glass-blowing as it is described above. Wooden or metal molds were constructed, and the molten gather of glass was inserted into the mold and blown until it took the shape of the mold. As is immediately evident, this process speeded up production. It is like the difference between

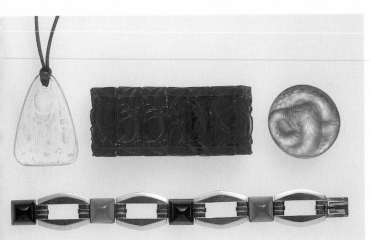

(Clockwise from top left): Opalescent; triangular glass pendant molded with two flowers; "bracelet sophora," a cobalt-blue glass bracelet with 14 rectangular links molded in relief; circular brooch of clear and satin-finished glass, molded as a coiled serpent; a Laclache frères chrysoprase and onyx bracelet

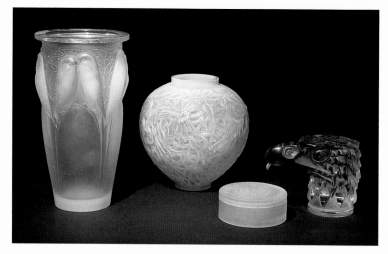

(Left to right): "Ceylan," an opalescent glass vase; "Gui," a blue-stained vase; frosted-glass box; and "Eagle Head," a powder box and cover

shaping cookies by hand and using a cookie cutter. Although the use of molds decreased the need for glassblowers skilled in the free-hand shaping of objects, the process required a different set of skills, for example in precisely judging the moment when the glass was solid enough to remove from the mold. Glassworking remained a highly skilled profession.

The Molds

In order to survive the intense heat of the glass without wearing out quickly, the molds were usually made from steel. Each mold was a precision-machined object that was costly to make, and in order to justify the expense, a large number of glass objects had to be made from each mold.

Press-molding

Techniques for blowing glass into molds were developed in antiquity, and around 1921, a revolutionary adaptation of the technique was adopted by the Lalique factory at Wingen-sur-Moder.

The technique required a machine that was similar to a handpress. This glass-pressing machine, usually on wheels to facilitate movement around the factory, resembled a drill press, with a long lever attached to a plunger and a tabletop surface to hold a mold.

Press molding facilitated the mass-production of vessels that looked like they were handblown, but were instead made by first pouring molten glass into metal molds. The hot glass was then pressed into shape with a plunger that forced the molten material outward toward the sides and into the cavities of the mold. Because the plunger had to be forced almost to the bottom of the mold, press-molded vases could not be designed with narrow necks, like some blown-glass vessels: The opening at the top of the vessel had to be at least as wide as or wider than the base. This design limitation was counterbalanced by the attractive, sharply sculpted, freshly minted quality of the finished vessels. Moreover, the speed of the process cut the unit costs of production considerably, making the factory more profitable.

Relieving stress points: When the process is judged complete, the finished vessel is cracked off from its pontil and goes into the **_annealer_** or **_lehr,_** an oven where, over a period of hours or days, high heat is slowly decreased to room temperature, and where the stresses that have built up in the glass from all the reworking are diminished. If the glass cools too rapidly, it will break or explode from the unrelieved stresses. It is not uncommon for glass to fracture in the annealer, despite these precautions.

At the Lalique factory, the objects were placed on a long conveyor belt, called the _chemin de fer,_ that moved them slowly through the specially constructed annealing furnace, hot at one end and cool at the other. This operation generally lasted about 24 hours, depending on the thickness of the glass.

Finishing: Afterward, the glass was inspected and **_cold-worked_** with special polishing and buffing equipment—for example, the removal of the pontil rod leaves a scar on the base of the vessel and this must be polished away. Some objects might be etched with acid. Finally, the artwork was signed and shipped or stored for future sale.

Adding color: Most of the glass that Lalique made was clear or of solid colors like amber and emerald green. He made a conscious effort to follow a different course from contemporaries like

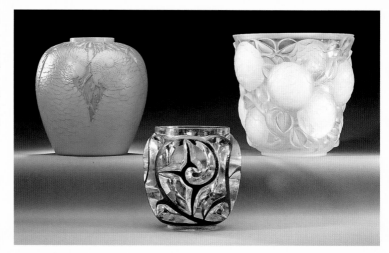

Émile Gallé, whose individual works were characterized by a panoply of colors, sometimes overlapping one another.

In one sense, this decision made it easier for Lalique to make glass. Color in glass can be very expensive because of the complexity of the chemical formulas and the scarcity of some ingredients such as gold and silver. Because different metals heat and cool at different rates, not all colors are compatible. This means that even after a piece is blown and annealed, if incompatible colors are used, the glass may break apart on its own after it is taken out of the annealer. Much trial and error and associated cost go into producing a new series of vessels or sheets of stained glass.

Color can be added to blown vessels at many stages in the forming process. Special pots can be used in which different colors are melted, and the first gather might be of red, or blue, or white, and so forth. Additional layers of color can then be gathered on top of the first gather, or pressed into, dripped on, or wound around the vessel.

Lost wax, or *Cire Perdue*

The lost-wax technique (*cire perdue* is French for "lost wax") that Lalique used to create glass sculptures or vessels (from around 1900 to 1905) was directly derived from ancient metal-casting techniques. The craftsman started by creating a clay model (a positive), then a plaster hollow form from the clay (a negative). A positive wax casting could then be made from this plaster mold, and a high-temperature negative mold could be formed around the wax. Once the wax was burned out of this mold (thus, the name "lost" wax), molten glass could be introduced into the hollow cavity, where it would take on the shape of the wax and become a positive glass sculpture or vessel. The advantage of this multi-step process was that multiple wax impressions could be taken from the original mold, allowing multiple castings in glass to be created. So, contrary to the impression given by the term "lost wax" process, the technique was ideally suited to creating limited editions, although after about 1919, Lalique seems to have decided to make only unique examples using this technique.

Moreover, the process preserves the most delicate impressions made by the sculptor, even sometimes his fingerprints! This delicacy, coupled with a waxy sheen or glossiness of the surface, lends an exquisite preciousness to Lalique's *cire perdue* pieces.

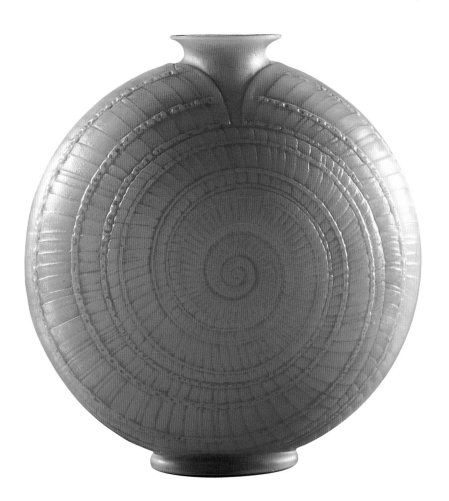

World War I and the Verrerie d'Alsace

Germany lost World War I, which lasted from 1914 to 1918 and interrupted industrial production in France, but resulted in the recovery of the territories of Alsace and Lorraine (ceded after the Franco-Prussian War of 1870–71). The French government was eager to promote industrial development, and this coincided with Lalique's ambition to expand his glass factory to meet his goals of mass-production. Lalique built a new factory in Alsace, on about 12 acres of forested land, at Wingen-sur-Moder. The new location had everything he needed: access to skilled workers, high-quality sand for glassmaking, and wood for fuel. He named it "Verrerie d'Alsace" and began to mass-produce table glassware and goblets, keeping the more intricate and costly production at the Combs-la-Ville factory.

Sound Byte:

The problem was no longer to seduce, but to convince.

—Felix Marcilhac, author of the
catalogue raisonné of René Lalique, 1989

Watch out, Picasso!

World War I had ended and change was in the air! The Communist party was gaining ground in Russia, and everywhere in France there

OPPOSITE
"Snail" (*Escargot*)
Amber glass vase,
discus-shaped with
everted rim molded
as a spiraling shell
motif

OPPOSITE
(Clockwise from
top left):
"Open Wave"
(*Ondine ouverte*), an
opalescent molded
glass bowl;
"Roscoff," an
opalescent
glass coupe;
"Coupe calypso,"
an opalescent glass
bowl; "Flat wavy
plate" (*Assiette
plate ondine*), an
opalescent molded
glass plate

was a growing interest in the elimination, or at least blurring, of class distinctions. The idealistic side of Lalique was evidenced in a new goal he set for himself: to make beautiful artworks for the household as well as for the precious world of high style. As an artist, he was perfectly positioned to accomplish this goal: While painters and sculptors work in a studio, laboriously making one painting or sculpture at a time, Lalique possessed two factories, metal molds that allowed serial production, and a large team of skilled artisans to execute his designs. He changed the numbers game in art: A highly productive painter might produce 2,000 paintings during a lifetime, but Lalique's factories could easily churn out that many vases, bowls, and goblets in a few days or weeks!

Ever the savvy businessman

Lalique's social idealism was matched by a heavy dose of capitalist realism. He encouraged multiple sales by designing complete table settings and by pricing individual pieces within the range of middle-class buyers. He began to open a series of shops throughout the world, and to fill special orders. For example, a vintner in Alsace ordered 12,000 examples of a drinking glass titled "Clos Sainte-Odile." No stranger to the old business maxim "sell the customer one thing, then sell that same customer something else as well," Lalique later added other accessories for wine drinking, including a decanter.

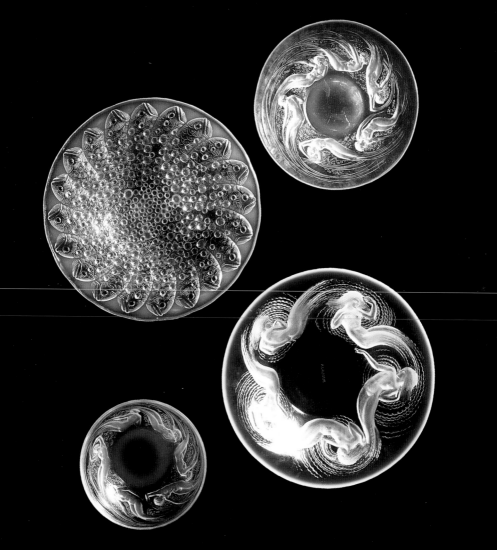

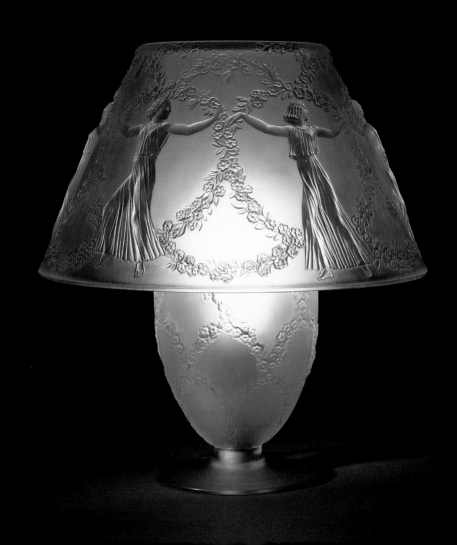

A gift of state

During the presidential trip of Woodrow Wilson to France in December, 1918, The president's wife Edith received a magnificent corsage decorated with olives and eight opalescent doves of peace perched in a tree made from diamond encrusted branches (they were actually pigeons, but Lalique, like a magician, decided that for the purposes of a state gift they would be doves).

The *Paris*

On July 21, 1921 the *paquebot* (packet boat) *Paris* set sail from Le Havre to New York on its maiden voyage. It was the first of a new series of luxury liners constructed after the war, and the French saw it as an opportunity for cultural propaganda. Lalique was engaged to create luxurious interior elements for the ship, including decorated doors and a clock

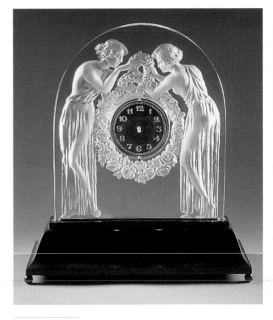

ABOVE
"Two Figurines"
Molded and engraved glass clock

OPPOSITE PAGE
Table lamp

75

"Teheren," a molded
glass vase (left) and
"Five Swallows"
(*Cinq Hirondelles*), a
molded, enameled,
glass clock

face adorned with butterflies (indicating the daylight hours) and moths (indicating nighttime hours).

Critical response

In December 1921, Gustave Kahn wrote an article in *L'Art et les Artistes* assessing Lalique's evolution after the war, and emphasizing that he had mastered the effects of line and transparency in glass. Although Lalique chose to stick mostly with clear and frosted glass, he managed

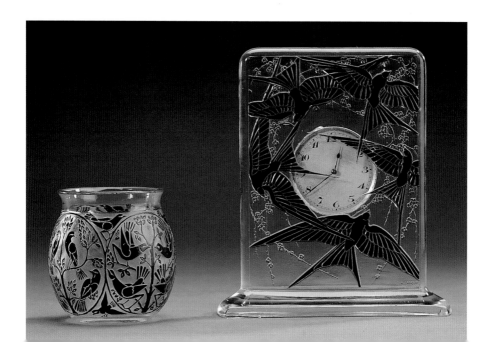

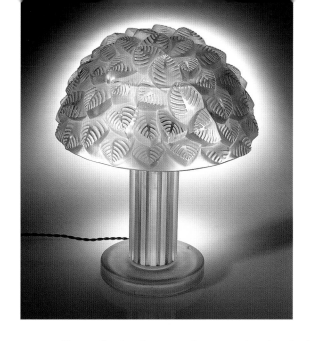

Frosted-glass table lamp

to incorporate effects of color because the artworks absorbed and reflected their surroundings; and he added visual interest to the objects by contrasting matte and glossy surfaces, thick and thin, light and shadow.

Glass in architecture

From the 1920s on, Lalique focused heavily on the use of glass in architecture. In 1922, he introduced effects that resembled frost on

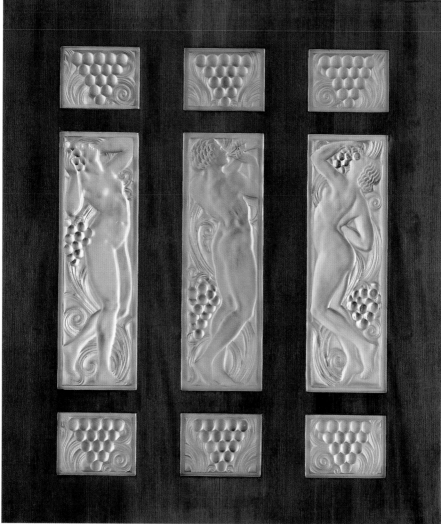

windowpanes at his booth at the Salon des Artistes, and that same year he created a doorway for the Musée Pasteur in Strasbourg, with a molded glass plaque that depicted the famous scientist **Louis Pasteur** (1822–1895), who had discovered that most infectious diseases are caused by germs. At the same time, he made some simple jewelry, including pendants and necklaces, in pressed or molded glass, on silk cords, with lizard and serpent themes.

Command performances

In 1923, Lalique participated in the decoration of Madeleine Vionnet's couture (clothing design) house on Avenue Montaigne in Paris. Working in collaboration with Chanut (the architect for the Galeries Lafayette in 1900), Lalique produced a spectacular environment suitable for the dramatic entry of models wearing the latest in high fashion. He embellished an arched doorway with sliding panels and installed flattering, theatrical glass lighting in the main salon. It was a vivid demonstration of the role that glass could play in orchestrating the ambience of a space.

In the same year, the president of France, **Alexandre Millerand** (1859–1943), who had been the Minister of Commerce and Industry from 1899 to 1902, ordered a table service that Lalique christened "Élysée" (since 1873 the Élysée Palace had been the residence of the president of the French Republic). It was a highlight of the Salon d'Automne. And for the Exposition de l'Union Centrale des Arts Décoratifs,

Frosted-glass architectural panel for a Pullman car on the Cote d'Azur train, consisting of elongated panels and six smaller rectangular plaques all set in a fitted sycamore frame 1929. 36 3/4 x 31 1/2" (93.3 x 79. 4 cm)

Pavillon de Marsan, Lalique created a complete table service, a move toward a unified, yet mass-produced, artistic environment for the dining table. His success in this area was highlighted when Pierre Olmer, in 1924, writing an article about Lalique—"Verreries de René Lalique"—in *Mobilier et décoration d'intérieur*, praised Lalique for exploring and creating a complete and refined line of table furnishings in the space of just a few years.

Lalique on a grand scale

As he gained confidence as a glassmaker, Lalique began to seek large-scale architectural commissions. These included works for the Normandy cruise liner, the luxury Orient Express train, fountains on the Champs Élysées in Paris, and windows in the Coty Building on Fifth Avenue in New York (currently Henri Bendel), the Oviat Building in Los Angeles, and the Teien Museum in Japan.

Bouchons de radiateur

One of Lalique's most handsome and enduringly popular series was the group of about 30 sculptures he designed as hood ornaments (i.e., *mascots*) for automobiles. The automobile really came into its own after World War I, and by 1925 Lalique was producing a series of mascots that included prancing horses ("cinq chevaux"), a comet complete with tail, a fierce eagle's head, two dragonflies, and a Victory head. Many of

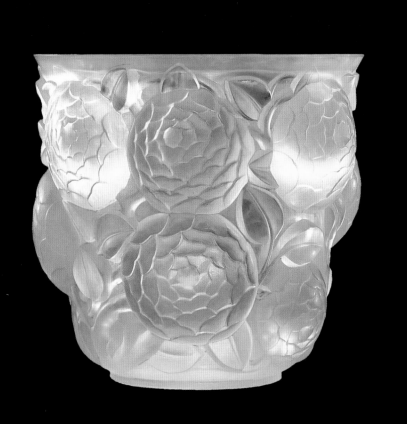

the designs were geometrically stylized to reflect the effects of intense speed: for example, the hair on the head of Victory was swept back as if carried away by the wind. The mascots were in fact not very practical: They were either too fragile or too distracting, especially the ones that were internally illuminated and supplied with color filters for changing the mood of the light.

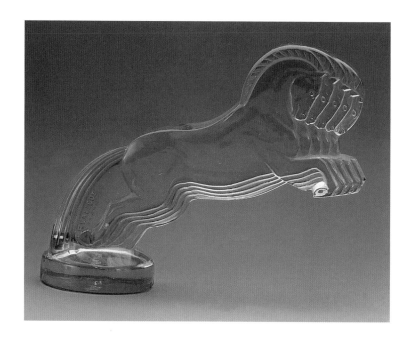

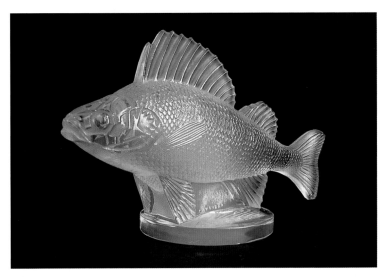

"Perche"
Clear, frosted,
molded-glass
hood ornament
(car mascot)

Sound Byte:
It is little wonder that few mascots were used on a regular basis—many of the mascots were very large and must have given the driver quite a challenge in driving the cars at night—in fact I actually wired up a Victoire to the front of a 1929 Bentley 8 litre and drove this car through central London at 3 am on a Sunday night to try it out. The effect was truly awe inspiring, but it was just as well there were few cars driving that memorable night!
—Tony Wraight,
Lalique collector, 2000

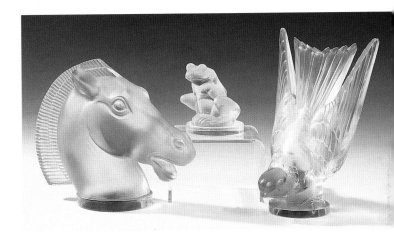

ABOVE
Three hood ornaments (car mascots). From left to right:
"Longchamps, "Frog" (*Grenouille*), and "Swallow" (*Hirondelle*)

LEFT
Car ornaments, perfume bottles, and an ink well

Hot glass helps define the roaring twenties

Lalique seemed to own the 1920s in the decorative arts. His new factory at Wingen gave him a fabulous *machine*, run by a skilled team, for the mass-production of art on a scale that even Picasso could not match. Within a ten-year period (1920 to 1930), he designed several hundred new vases, as well as architectural glasswork, tableware, car mascots, and so forth. One new technique that he developed, called **press-molding** (see The ABCs of glassmaking on page 66), allowed him to produce stylized vessels that were ideally suited to the emerging Art Deco style. The vase *Tourbillons* (Whirlwinds), designed around 1925, became an instant masterpiece and remains an icon of the era.

Glass necklaces

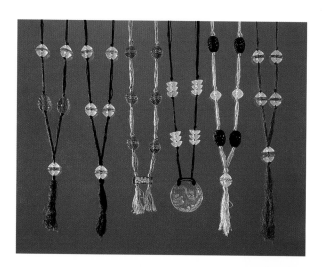

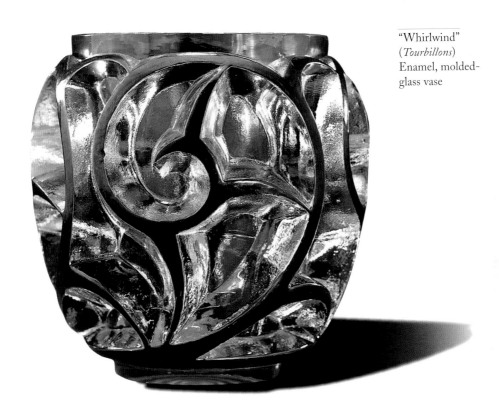

"Whirlwind"
(*Tourbillons*)
Enamel, molded-
glass vase

Art Deco

Art Deco, also called Art Moderne, was the major style in decorative arts in the period between the two world wars of the 20th century, flourishing from roughly 1920 to 1945, although starting a bit later in the United States than in Europe. Unlike Art Nouveau, which was named by the artists who created the style, Art Deco was not used as a descriptive term until the 1960s when a group of curators coined the phrase.

Sound Byte:
Art Deco is the clearest sign of a measure, not just of tolerance, but acceptance of the value of other cultures.

—ARTHUR CHANDLER, author, 1988

Art Deco emerged before a worldwide audience at the 1925 Paris Exposition Internationale des Arts Décoratifs et Industriels Modernes. By its height in the 1930s, the style encompassed handcrafted luxury goods, mass-produced trinkets, Bakelite radios, film sets, and fashion as well as skyscrapers such as the Chrysler Building in New York City, and the grand ocean liner Normandy built in France.

Art Deco style was influenced by the bold but streamlined machine shapes that were evident everywhere in the design of airplanes and

steamships. Its preference for geometric ornamentation spoke with clarity in defiance of the melting shapes and ambiguous symbolism of Art Nouveau. If Art Nouveau was a drug that put you to sleep in order to make you dream, Art Deco was a bolt of lighting that energized all it touched. It drew its vigor from at least three major sources: (1) the Bauhaus movement in architecture, founded in 1919 by the architect **Walter Gropius** (1883–1969), who sought to make "modern artists familiar with science and economics, [and to] unite creative imagination with a practical knowledge of craftsmanship"); (2) the Cubist style in painting, developed by **Pablo Picasso** (1881–1973); and **Georges Braque** (1882–1963) in the first decade of the 20th century, whose style was described by one writer as consisting of "little cubes"; and (3) the Ballets Russes of **Sergey Diaghilev** (1872–1929) as well as a revival of interest in ancient Egyptian art (Tutankhamen's tomb was discovered in 1922) and in American Indian and African arts.

Aside from Lalique, the leading exponents of the style included the furniture designer **Jacques-Emile Ruhlmann** (1879–1933), the architect **Eliel Saarinen** (1873–1950), and the fashion designer **Erté** (1892–1990).

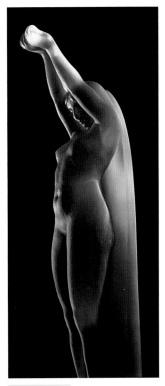

"Large Nude with Arms Raised"
(*Grande Nue bras ouverts*)
Molded-glass sculpture, c. 1920
Height: 26 ½" (66 cm)

RIGHT
"Sultane"
A clear, frosted-
glass cigarette
box with cover
c. 1922

OPPOSITE PAGE
(Left to right):
"Clos Saint-
Odile," a brown-
stained glass
statuette with
dish; "Sirène," an
opalescent glass,
satin-finished
statuette of a
mermaid;
"Drapée," an
opalescent glass
statuette

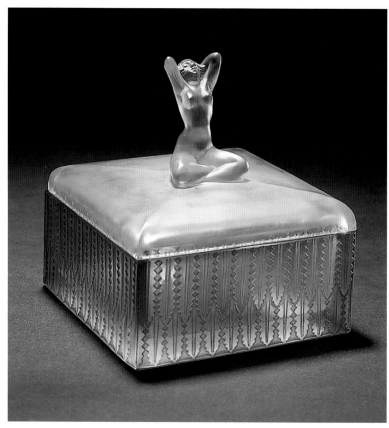

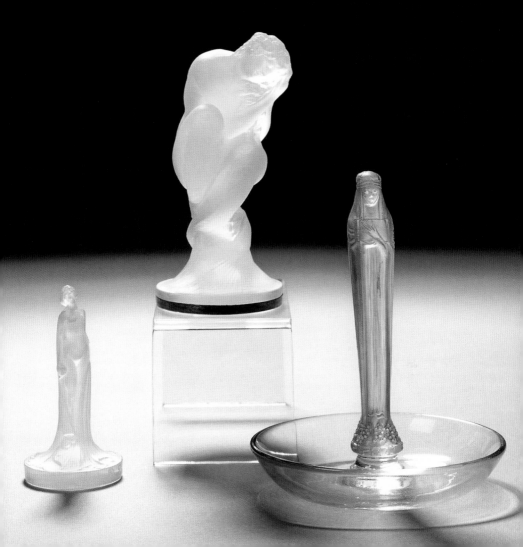

Paris rules!

OPPOSITE
"Frise Aigles"
Black vase

Paris between the world wars had truly become the City of Light that was announced by the 1900 Universal Exposition. As the self-confident cultural center of the world, it drew Americans like **Ernest Hemingway** (1899–1961), **Josephine Baker** (1906–1975), and **F. Scott Fitzgerald** (1896–1940), who were attracted to the city's open lifestyle and intellectual vibrancy. But in retrospect, the 1900 exposition was also perceived as something of a failure—attendance was below projections and it lost money. Should there be another grand but unwieldy French Expo?

Sound Byte:
I look at; I examine; a woman, a child, a bird in flight, whatever; a tree alive in the sunlight appears as fish beneath the water; suddenly the harmony of a shape, a gesture, a movement, becomes locked in my mind, combining with other ideas I have already acquired. Only when I have turned it all over and over in my head, does the idea, the oeuvre, ripen, and only then do I harvest it.

—René Lalique, 1925

The solution that the French arrived at was the 1925 Exposition Internationale des Arts Décoratifs et Industriels Modernes. This would be

OPPOSITE
LEFT
"Cardamine"
Art Deco table
lamp

RIGHT
Art Nouveau
table lamp

a show with a focused theme. Instead of a multi-volume encyclopedia, the French would provide the world with a road map to the best and most innovative in contemporary design and manufacture. The Art Nouveau style, by 1920 somewhat musty and antiquated, would be left behind, and the most advanced French taste and refinement would be on display to capture and captivate a worldwide audience. Among the accomplishments of the exposition was the official recognition given to the arts of Africa, previously dismissed as insignificant but now recognized as a key source for modern art and vigorously integrated into the emerging Art Deco style. Noticeably absent from the exposition was the United States, where the Art Deco style emerged several years later.

Sound Byte:

In 1889, the power of unadorned iron; in 1925, the poetry of decorated crystal.

—ARTHUR CHANDLER

The light fantastic

Lalique realized that the 1925 exposition would provide an invaluable showcase for his conviction that glass was the ideal material for the modern era: infinitely malleable into a universe of shapes, more resistant to wear than stone, its brilliance a greater overall impact than diamonds.

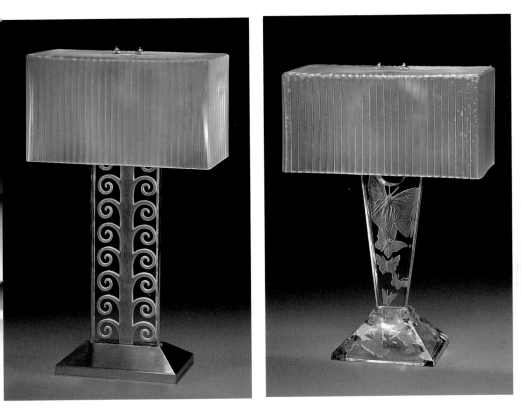

Lalique's presence at the exposition was outstanding. Passing through the entrance on the Place des Invalides, visitors greeted his most astonishing creation, a collaboration with the architect Marc Ducluzeaud. It was a fountain-obelisk, set directly in front of Lalique's own pavilion, and christened the grand "Fontaine des sources de France."

The fountain symbolized and celebrated the streams and rivers of France. The focus was a gently tapering pyramidal element 15 meters tall (over 45 feet), made from a stack of 17 octagonal stages, like a wedding cake. One hundred twenty-eight glass caryatids, each with a water

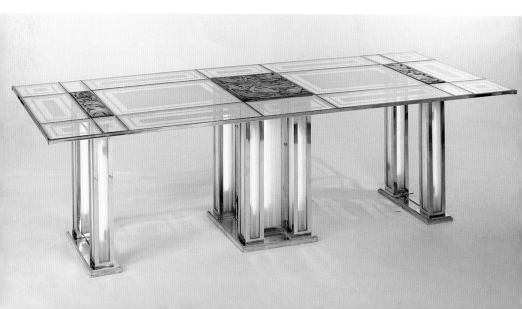

jet emerging from its base, acted as pillars supporting every stage, and between them were glass panels, illuminated from within by electric lights. Water and light and glass were knitted together dramatically! There survives a contemporary black-and-white photo of the fountain at night, partly surrounded by chairs filled with spectators enjoying the spectacle.

During the daytime the fountain was less impressive, and became the subject of some fierce and funny criticism. It was described as a giant "herring-bone." The water jets were compared to the strands of a giant liquid spiderweb. And some even likened it to a giant banana with tiny caryatids arranged on its surface.

At the end of the Expo, Lalique offered the fountain to the city and people of France (partly to avoid the 100,000 francs that it was estimated it would cost to disassemble the structure). The municipal council of the city refused the offer, saying that the fountain should not remain alone, facing Les Invalides across the Esplanade. In fact, almost all of the monuments of the 1925 exposition have since disappeared.

In February of 1926, Lalique removed the masterpiece of glass, selling the statuettes in his shop to defray expenses. They sold so well that he made additional copies to sell as souvenirs.

OPPOSITE
An asprey glass-and-chrome, metal dining table inlaid with Lalique panels molded with swallows among berried branches, green staining on three of them, with metal tressel supports inset with satin-finished glass, illuminated with neon-strip lighting panels

Utopia

At the center of Lalique's efforts for the Expo was a spare modern pavilion that opened on June 19, 1925. A wide set of stairs led to the entrance, composed of four bays of glazed windows encrusted with sparkling pressed glass tiles. Entering through one of these window-doors, visitors were confronted by a monumental vase that formed the centerpiece of the space. This was constructed from molded-glass panels, several along the shoulder of the vessel decorated with a cavalcade of horses, and held together on an armature of "melchior." The starkness of the interior contrasted with the crowded interiors of many of the other pavilions, and provided a handsome backdrop for cases filled with Lalique's most important contributions to glassmaking, his *cire perdue* pieces. Overall, the pavilion and its interiors projected a utopian concept of life enhanced by art. It was a vision of spare elegance. The pavilion was demolished at the end of the exposition.

A presence throughout the Expo

Lalique had been named chair of "la Classe de Verre," the glass section at the exposition, and wrote an introduction to the exhibition guide that reflected on the new roles played by glass in architecture and the "ensemble" of table settings. In fact, the Expo constituted the moment when Lalique sought to prove, and succeeded in proving that glass can serve any purpose.

In addition to the monumental fountain and the austere pavilion, Lalique created a dining room in the Sèvres Pavillion to represent his idea of a total decorative environment. The decoration on the marble walls showed a forest and hunt scene with hounds and boars. A marble table at the center was set with Lalique tableware. It was impressive, but critics found it icy cold and inhospitable to the idea of convivial dining.

Asked to embellish the French perfumes section of the Pavilion of Perfumers at the Expo, Lalique played with the concept of a "Perfume Fountain" that would spray out jets of different odors, and he decorated the Roger & Gallet perfume exhibition area, encrusting the walls with glass designs representing flowers. Throughout the rest of the Expo, Lalique provided details and decorations, displayed his latest creations in production glass, and generally made his presence felt as the leading glass artist of the era.

"When I'm 65"

The 1925 Paris exposition represented a significant triumph for René Lalique, who turned 65 that year. He could look back over a career that spanned two media, jewelry and glass, and two styles, Art Nouveau and Art Deco. At a time in life when many successful artists turn reflective, Lalique was determined to move full speed ahead.

Expansion

Lalique had positioned himself well for further growth despite the heavy costs of the Expo. As his next step, he established a network of exclusive representatives in the United States, South America, and North Africa. New designs included a Lalique clock *Night and Day,* with Male (day) and Female (night) figures pressed into a glass plaque that encircled the mechanism of the clock. The figures appeared to float in space, and the blue tint of the glass evokes an underwater environment.

In an attempt to create a new district for luxury goods apart from Place Vendôme and the area around the Opéra, the Galerie des Champs-Élysées was opened on that grand avenue in 1926. Its large atrium spaces showcased elegant works by Lalique—including a Lalique fountain and signature Lalique embellishments, such as shining architectural decorations in glass and external lantern lights.

"Night and Day" (*Nuit et jour*)
Topaz glass clock, c. 1925
Height: 14 ½" (37.5 cm). This extraordinary clock came in a variety of hues; it was Lalique's most lavish and expensive clock

Also the same year, he decorated the new Worth shop in Cannes, including large glass letters that spelled out WORTH on the façade. He was also commissioned to create three windows for the church of Saint-Niçaise at Reims, which he made from a pressed yellow or amber glass. The theme was a central standing angel flanked by two genuflecting or kneeling angels, all three with hands clasped in prayer.

Although the public loved Lalique and showed it by buying his work in ever greater quantities, some critics continued to judge his work as icy cold—as, for example, the columned glass space he created for his exhibit at the Salon d'Automne of 1926.

Outlandish bathtubs and elegant cabinets

The late 1920s and early 1930s were a busy time for Lalique as he accepted commissions for architectural projects and participated in various exhibitions. At the Salon d'Automne of 1927, he showed a glass bathtub, which one critic called an "inordinately large flowerpot." Criticism did not, however, deter Lalique from experimenting. His guiding philosophy during this period—namely, that glass could be

Sound Byte:
Lalique is at once sculptor, painter, enameler , and goldsmith.
—IRENE SARGENT, writing in *Craftsman*,
volume 3, November 1902

anything—often grated on the refined temperament of the French cultural world. Some of his experiments succeeded brilliantly—for example, he displayed an elegant liquor cabinet in plum wood with glass panels portraying satyrs that was well received. But taking a bath in a tub that looked like a cross between a planter and a dirty block of ice? No way!

Sound Byte:
Without ceasing to be an artist, René Lalique has become an industrialist…in what way would a drinking glass, a wine carafe, the platter of a crystal dessert set signed by Lalique be more harmonious in form, more charming in ornament, more beautiful in material, if there were only one, two, or ten of them in the world?

—GABRIEL MOUREY, introduction to
the 1932 Lalique catalog

Gaining momentum

Lalique's furious activity preparing for the 1925 exposition gave him the confidence and organizational skills to take on many monumental projects and to market his products to a larger audience. In 1927, the ocean liner *Ile de France* was launched with Lalique ceiling lighting fixtures. In 1928, he was commissioned to decorate the Côte d'Azur Pullman Express train cars, which he embellished with glass panels in the

OPPOSITE
Art Deco cocktail bar trolley (liquor cabinet), inset with two clear, satin-glass panels with sprays of stylized poppies, each inscribed R. Lalique

dining cars. In 1929, he displayed in London a massive door in metal and glass, weighing over a ton, that opened and closed in silence, like the door of a bank vault.

By this time, his car mascots had become famous. Royalty, including the Queen of Spain, sought them out. In 1930, he created one of his most imposing ensemble works: a dining room for Madame Paquin. And in 1932, he completed the residence decorations for prince Asaka Yasuhiko, near Tokyo, Japan.

The 1932 catalog

In 1932, Lalique's company, René Lalique & Cie, produced a catalog illustrating the hundreds of items available for sale, ranging from boxes and candy dishes to necklaces and pendants, spirit burning censers, ashtrays, bowls, plates, vases, mirrors, clocks, statuettes, and dinner services that include tumblers, trays, and bottles. Among the most expensive items were the vases: the *Antelope* vase sold for 2000 francs (colorless glass) or 2200 francs (colored glass), *Tourbillons* for 600 (enameled) or 650 (color). But a simple *Lotus* tumbler, in colorless glass, could be purchased for 11 Francs.

The catalog showcased many of Lalique's most popular designs. Model 896 was a massive *Serpent* vase, whose conical top is all that shows beneath a massive, muscular, coiling snake that appears to be intent on strangling the container. The scales are picked out in relief, creating a regular geometrical effect that is a pleasing counterfoil to the rather

OPPOSITE
(From left to
right): An opales-
cent clock; black,
glass perfume
bottle and stopper;
rose perfume
bottle; large
perfume bottle;
car ornament

terrifying reptile. Other vases depict fish in Escher-like interlocking patterns (Models 1015, *Salmonides* and 1002, *Marisa*). (The Dutch artist **Maurits Cornelis (M.C.) Escher** [1898–1972], was famous for his mind-boggling depictions of physically impossible situations, most of which were created from the 1930s onward.) A few had boldly designed, massive handles that seemed weightier than the vases to which they were attached (Models 1024, *Pétrarque,* and 1030, *Margaret*). Other vessels took their inspiration from historical themes (Model 961, *Cluny*), or were decorated with motifs that repeated natural forms in overlapping layers, such as Model 932, *Coquilles,* with a pattern of seashells.

The do-it-yourself retrospective

A major Lalique historical survey opened on February 10, 1933, at the Pavillon de Marsan, inaugurated by the Minister of Education and the Director General of Fine Arts. The exhibition occupied the central hall of the Musée des Arts Décoratifs at the Louvre. Lalique, who was an energetic 73 years old, oversaw the organization, and in acting as curator, he included examples from all his various forms of artistic production from roughly 1890 through 1933, without a care in the world about chronological layout. Unfortunately, no catalog was produced to document this major retrospective, although from all accounts in the press it was a popular success.

Final things

In 1935 the stunning ocean liner S.S. *Normandy* sailed with interior fittings and tableware by Lalique. This great success was to be among the artist's last major projects. Clouds of war were gathering in Europe and Lalique was in his seventies. In 1937 the Combes-La-Ville factory permanently closed and in 1940 the Wingen-sur-Moder factory shut its doors, not to reopen until after World War II.

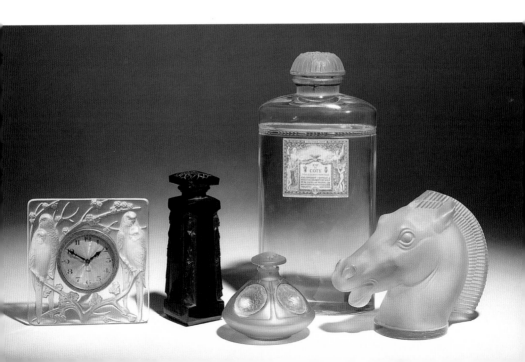

OPPOSITE
(Left) "Alicante," an electric-blue, satin-finished, oviform glass vase; (right) "Palestre," a frosted-glass vase

On May 5, 1945, Lalique died at age 85. The obituary in *The New York Times* was headed with a dignified photograph of Lalique in old age, and noted that his "influence was paramount for many years on French art, jewelry and glassware" and that his "very novel" designs created a sensation at the Paris 1900 Universal Exposition. *The Times* wrote that before World War II, "the Lalique factory provided the sole industry for the town of Wingen in Alsace. Visitors commented on the unusual degree to which art was preserved on a modern assembly line."

Rebirth from the ashes

World War II led to the closing of Lalique's factory at Wingen, and during the liberation of France, the factory, as well as the handsome house nearby that Lalique had constructed for himself, were largely destroyed. Tragically, the voluminous archives of the company were lost. But by 1946, Lalique's son Marc succeeded in reestablishing production amidst the ruins of the factory, and by 1951, he had reconstructed the family business.

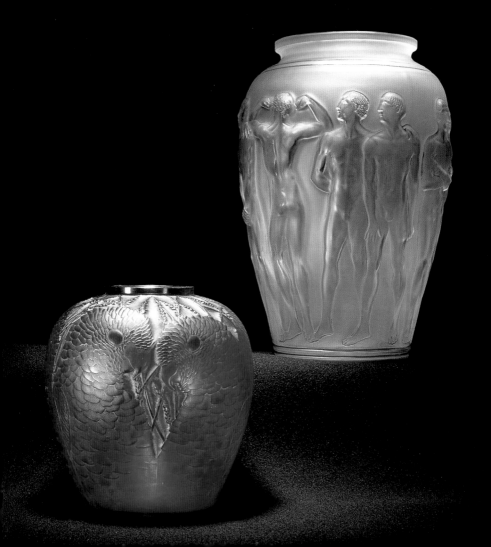

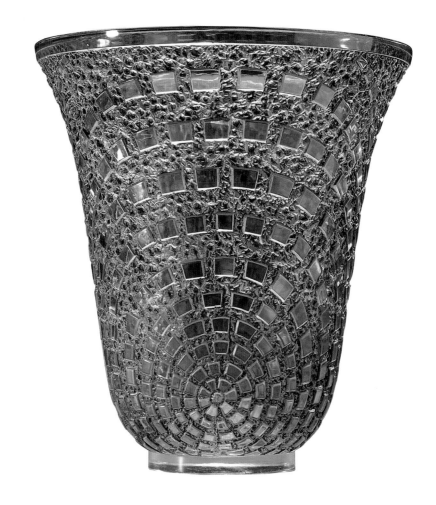

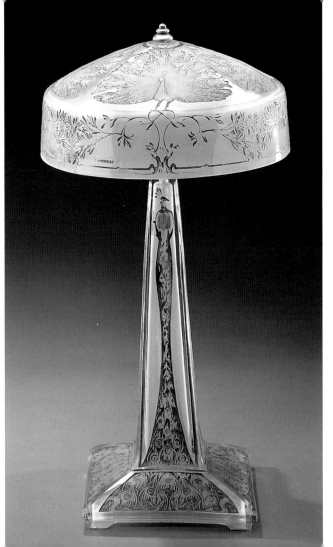

LEFT
"Paons"
Molded-glass table
lamp

OPPOSITE
"Damiers"
Molded-glass vase